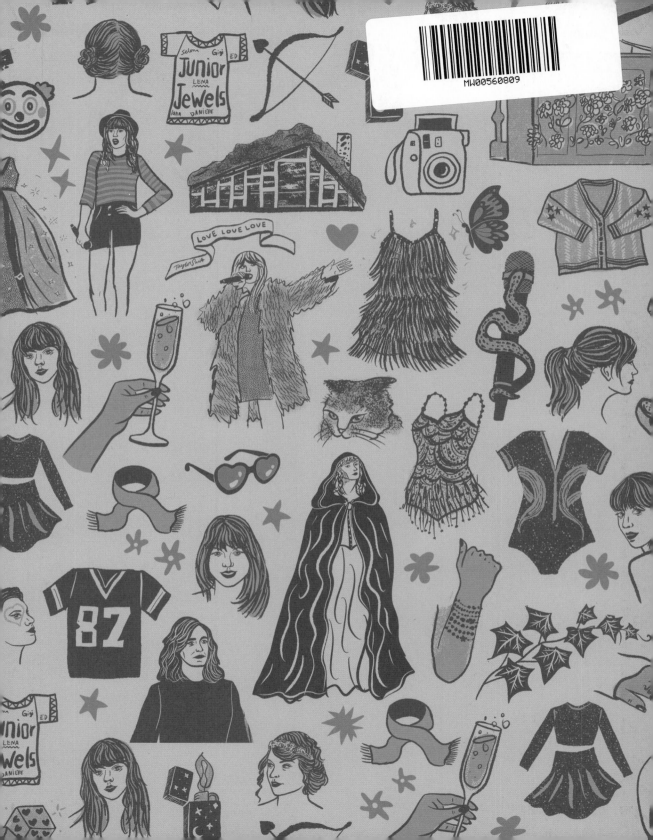

LONG
LIVE

LONG LIVE

THE DEFINITIVE GUIDE TO THE FOLKLORE AND FANDOM OF

Taylor Swift

NICOLE POMARICO

Running Press
PHILADELPHIA

Running Press
Hachette Book Group
1290 Avenue of the Americas, New York, NY 10104
www.runningpress.com
@Running_Press

First Edition: December 2024

Published by Running Press, an imprint of Hachette Book Group, Inc. The Running Press name and logo are trademarks of Hachette Book Group, Inc.

The Hachette Speakers Bureau provides a wide range of authors for speaking events. To find out more, go to www.hachettespeakersbureau.com or email HachetteSpeakers@hbgusa.com.

Running Press books may be purchased in bulk for business, educational, or promotional use. For more information, please contact your local bookseller or the Hachette Book Group Special Markets Department at Special.Markets@hbgusa.com.

The publisher is not responsible for websites (or their content) that are not owned by the publisher.

Photography courtesy of Shutterstock and Getty Images

Print book cover and interior design by Justine Kelley
Illustrations by Justine Kelley

Library of Congress Control Number: 2024939741

ISBNs: 978-0-7624-8941-1 (hardcover), 978-0-7624-8942-8 (ebook)

Printed in Italy

Elco

10 9 8 7 6 5 4 3 2 1

For Penelope—
Love you to the moon
and to Saturn

CONTENTS

INTRODUCTION

· ·

Where were you when Taylor Swift surprised the world by dropping *Folklore*? What was going on in your life when you rocked out to "Blank Space" and "Wildest Dreams" on *1989*? How did you feel when the countdown appeared on the screen at the Eras Tour, and suddenly the entire stadium around you was buzzing with excitement? You may or may not have the answers to all these questions, depending on how long you've been a Taylor Swift fan or if you were able to snag an Eras ticket, but you no doubt have countless memories tied to Taylor.

When it comes to memories, music can be a powerful thing—and for me, every era of Taylor Swift's music takes me back to who I was when each album came out. When I hear her self-titled debut album, I can feel the wind on my face as I drive my first car down the highway, my best friend in the passenger seat, the summer after I graduated from high school. Any song from *Red* takes me back to the busy

streets of New York, when I was in college and interning at *Seventeen* magazine, missing my long-distance boyfriend and trying to figure out who I was going to be. And when I hear *Folklore*, it's 2 a.m. and I'm rocking my newborn baby, and it feels like my daughter and I are the only ones awake in the entire world during a scary time when I was trying to learn how to be someone's mom for the very first time.

But to me, that isn't the only magic of Taylor's music. It's in knowing I'm not the only one with stories like these. It's in the way she's created a community of people who have been brought together by her music. We all share a comfort pop star. Taylor is the invisible string connecting us all to one another; we're total strangers who not only share the same favorite songs, but who feel understood by those songs. Providing that understanding has always been one of Taylor's strengths.

Like many other female-dominated fandoms, Swifties often end up being the

butt of the joke. When people say they don't "get" Taylor Swift, they're right—they don't get it. But if someone took their biggest, messiest feelings and put them into words in a way that sounded beautiful, in a way that made them feel so heard and understood, they'd probably understand why we are all so dedicated to Taylor, too.

And if Taylor herself is the invisible string connecting all of us as fans, there's another thread of gold connecting Taylor to *us*: the shared code that we have worked together to build since her debut album was released in 2006. The relationship that Taylor and her fans have is unlike anything other artists have been able to generate, and so is the world we've built around being a Swiftie. It's not a spectator sport—for us or for Taylor. From the Easter eggs she's dropped to fill us in on her upcoming albums to the details about her personal life that we've gleaned from her interviews and social media posts, we fans have created our own lore around Taylor. This multiverse is made up of hundreds of both confirmed and unconfirmed threads of mythology that not even Taylor herself can stop from happening at this point.

Swifties have fashioned their own culture around their favorite singer while also forming strong bonds with one another, and over the years, our numbers have multiplied many times over. Every chance she gets, Taylor makes sure that we know that the love we feel for her is mutual—whether she's inviting us to her house to listen to her latest album before anyone else or sending us Christmas gifts she picked out herself. These are actually things some unbelievably lucky Swifties experienced in her early eras.

Being a Swiftie is and, for the most part, always has been *fun*, even if it does come with homework sometimes (*1989 (Taylor's Version)* track list Google puzzle, I'm talking about you).

Being a Swiftie also means holding power. After all, Taylor might be the one smashing records, but we are a big part of that. Swifties are capable of incredible things—raising thousands for fans in need, one thirteen-dollar donation at a time, bringing attention to important causes, or even helping Travis Kelce secure his first number 1 single on the Billboard charts (no really, we did that with "Fairytale of Philadelphia"). As Taylor's popularity and influence grow, we all become even more powerful. Being a Swiftie means so many things. It's trading friendship bracelets in a parking lot. It's the fan who helps you draw a perfect 13 on your hand in the concert venue bathroom. It's the people you meet on the internet because they also love Taylor Swift and then they become some of your

best friends. It's knowing that you're not the only one combing the same social media posts for Easter eggs.

We are all so different, but when we are brought together for a common mission (like trying and failing to predict an album announcement so many times I've lost count), we are unstoppable.

One of Taylor's biggest strengths as an artist and an entertainer is her ability to constantly reinvent herself, and as she has evolved, we have been changing with her. With each era, Taylor found new ways to connect with her fans as the Swiftie movement continued to grow exponentially year after year, album after album, and even rerecording after rerecording. The song "Long Live" first appeared on her 2010 album *Speak Now*, originally as a thank-you to her band, but with its rerecording in 2023 it took on new meaning, becoming an anthem for Taylor's relationship with her fans—the ones who have stuck by her through life changes, both hers and theirs. That's what this book is all about, and why I thought *Long Live* would make a great title, too.

With the Eras Tour behind Taylor and a lifetime of being a musical legend ahead, it's time to look back on Taylor's extraordinary career and, most importantly, how her fandom has changed along the way. To enjoy this book, it doesn't matter if you're a Senior Swiftie who's been there since day one or if you discovered her music ten minutes ago and don't know where to jump in— everyone is welcome here.

In the pages ahead, we'll take Taylor's career era by era over the last two decades, breaking down all the best moments in her fandom and looking back on the ways she's found to stay connected to us as her music and personal brand have grown with her star power. Each chapter is packed with new details and behind-the-scenes stories from fans who were there and know what it was like to be rooting for our antihero at every stage, including me— an entertainment journalist and proud Swiftie since 2006.

Along the way, you'll have fun looking back on Eras Tour traditions and the fandom's inside jokes, you'll roll your eyes at our most embarrassing clowning moments, take in a Swiftie style lesson, and so much more. As we piece together the fandom's history, we'll see how our relationship with Taylor has been so well nurtured that it really has become an unmatched cultural force

building the career of one of the biggest artists of all time.

From Taylor's Myspace page to T-Party invites to Secret Sessions and beyond, we've all been through quite a transformation with Taylor as she's held our hands through the milestones of our lives, both good and bad.

If you can still remember the nervous feeling in the pit of your stomach on the first day of school when you were fifteen, this book is for you.

If you know that you could get there quicker if you were a man, this book is for you.

If someone has ever kept you like a secret, but you kept them like an oath, this book is for you.

And yes, if you've ever cried like a baby coming home from the bar, this book is for you, too.

At its core, this book is both a celebration of Taylor's career and a love story between her and the Swifties who have made it all possible. As Taylor told fans at the 2013 Billboard Music Awards: "You are the longest and best relationship I've ever had."

Let's explore it . . .

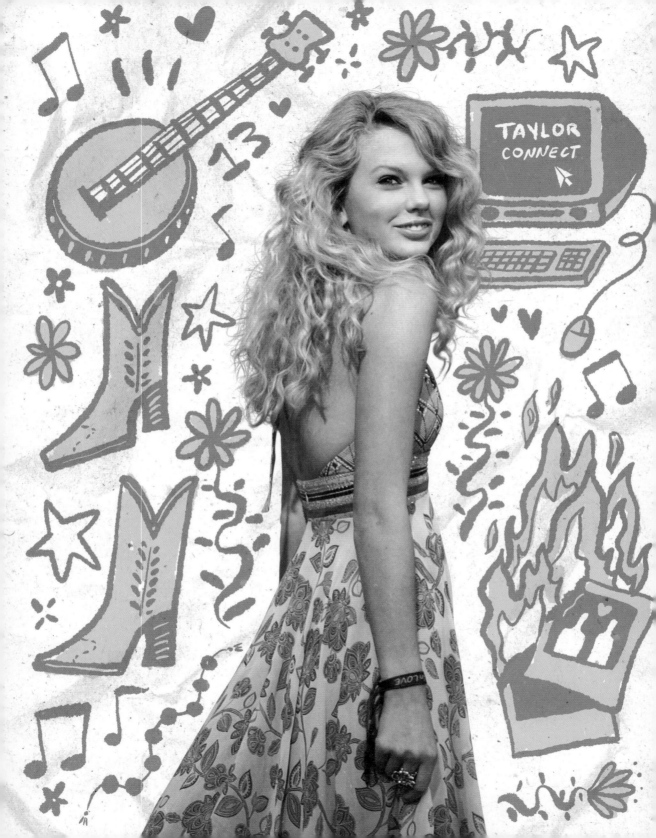

THE
DEBUT
ERA

I was a senior in high school in 2006 when I heard Taylor Swift for the first time. I've never been a big fan of country music, but my parents would listen to country radio sometimes. The local station was on in the car one day while I was running errands with my mom, and when "Our Song" started playing, Taylor's voice grabbed me right away— this wasn't another man singing in a deep voice about how he lost his truck *and* his girl all in the same day. Listening to her lyrics, I realized the way she sounded wasn't the only thing different about her. When we got home, I looked her up on Myspace, and almost twenty years later, I became an entertainment journalist who gets to focus on Taylor Swift every day.

A PLACE IN THIS WORLD

Anyone who's been a fan of Taylor Swift since her debut album was released on October 24, 2006, probably has had the unique experience of explaining who Taylor Swift is to at least one of their friends. Today, Swifties joke a lot about their "favorite indie artist," but back then, she actually was our favorite indie artist. She also sang with a southern accent, so a lot has obviously changed since then.

If it seems like Taylor is one of the most hardworking people in the music industry, that's because she is—and she always has been. Before, and even after, she signed with Big Machine Records (we'll revisit that can of worms later), Taylor did the legwork required to get noticed by the powers that be in the music industry from the time she was a kid.

"I made up this demo CD of me singing karaoke music and went to Nashville with my mom, and she would park outside record labels, and I would run in and be like, 'Hey, I'm Taylor. I'm eleven. I want a record deal. Call me," she said on a 2008 episode of *The Ellen DeGeneres Show*. (By the way, this was right around the time that Taylor sang the national anthem at the US Open in that fabulously patriotic American flag outfit, just in case anyone needs an iconic fashion moment like that one to ground them in the timeline.)

That method didn't quite work for her, but she didn't give up. Two years later, her family left their home state of Pennsylvania in favor of Nashville, Tennessee, where fifteen-year-old Taylor would soon sign a songwriting deal with Sony/ATV Tree Music Publishing.

Also around this time, Taylor and Scott Borchetta, the CEO of Big Machine Records, met for the first time at the legendary Bluebird Cafe after she invited him to see her perform. But even though his is the name that always gets tossed around when we're talking about the people who were instrumental in launching Taylor's career, one country star may have had some special influence on getting her signed: Toby Keith, who was working with Borchetta to launch Big Machine as a partnership with his own label, Show Dog Nashville. In 2005, Nashville's WSMV4 interviewed Taylor (at her high school, no big deal) ahead of the release of her first album, and she explained that she performed for him at her first meeting with Big Machine.

Taylor's first single ever, "Tim McGraw," came out in the summer of 2006, with her debut album, *Taylor Swift*, following on October 24. It's impossible to know if *she* knew she wouldn't be sticking with country music forever at that point, but choosing to begin her career there really was a genius move. At the time, she was filling a huge gap in the genre; successful young country stars were few and far between, and so were women. (And now for a mind-boggling fact: Only two women in history have ever debuted on the Hot 100 country chart at number 1 as a solo act. Those

women are Taylor Swift and Beyoncé . . . and Beyoncé didn't achieve this until 2024 with "Texas Hold 'Em.")

Starting out in this genre also gave her the chance to really flex the talent that makes the magic of Taylor Swift happen: her songwriting skills. Country music is known for its storytelling, and Taylor is nothing if not a storyteller. I wasn't a country fan when I discovered Taylor, but her words hooked me, and I know I'm not the only fan who feels this way.

Taylor knew how important writing her own music was, too, even then. While talking to *Entertainment Weekly* in July 2007, she said, "I didn't want to just be another girl singer. I wanted there to be something that set me apart. And I knew that had to be my writing."

While one of the biggest criticisms of Taylor's music at the time was that she only sings about boys, it was not true—not even on her very first album. Though Taylor certainly sang about love and heartbreak in songs like "Teardrops on My Guitar" and "Should've Said No," she also covered topics that listeners her age could relate to. "The Outside" was about feeling like she'd never fit in, while "Tied Together With a Smile" was written about watching a friend battle an eating disorder—common themes that a lot of us had experienced ourselves during that time of life.

How to Dress
for the
DEBUT
Era

COWBOY BOOTS

SUNDRESS

COWBOY HAT

CURLY HAIR

STACKED BRACELETS

LOVE, LOVE, LOVE BRACELET

"I was going through a really tough time in school and facing a lot of rejection among my peers," Taylor told Country Music Television (CMT) in 2006. "I found that I was alone a lot of the time, kind of on the outside looking in to their discussions and the things they were saying to each other. They really didn't talk to me. In the process of coming to that realization, I started developing this really keen sense of observation—of how to watch people and see what they did."

Her songwriting wasn't the only way she made an instant connection with her fans during her debut era. Since fellow teenagers were the ones who related the most to her music in the beginning, she treated fans more like friends. As Swifties before the term *Swifties* existed, we were on a level playing field with Taylor, so how did she find even more of us?

The same way the rest of us communicated in high school: on Myspace.

Not only did Taylor use *her* Myspace as her main, professional social media account where fans of her music could find her, but she used it to talk to her actual friends from school, too . . . as evidenced by the embarrassing screenshots that have surfaced in the years since of the comments she left. The internet is forever, Taylor! Even though, logically,

we know that Taylor was (mostly) a typical teenage girl at that point, looking back, it's still kind of funny to see a music legend leaving comments that any of us could have written ourselves. From the one where she begged her friend to take down a photo of her that she deemed "gross" to the ones where she's laughing about inside jokes, young Taylor was just like us.

She also had the perfect way—intentional or not—of making those of us who followed her page feel like her friends from school, too. Right there next to the list of her tour dates were her Myspace blogs, which she regularly updated to share peeks into her life with the people who had supported her career so far. Several times a month, she'd post her thoughts, and while some of them were unique to the experience of being a musician on the road, others were reminders that at her core she was still a teenage girl. She wrote about how she chose Little Big Town as the subject of a paper she'd just turned in for her English class, that watching the episode of *Grey's Anatomy* (on her iPod, no less) where Denny dies made her cry for ten minutes, and that her best friend Abigail had come over during holiday break. If only little Taylor had known that, one day, Little Big Town would win a Grammy for the song she wrote for them ("Better

Man") and that *her* music would be featured on *Grey's*.

In one of her Myspace bios (which are basically considered The Ancient Texts around here), she wrote about different things she loved at the time, like "random baking experiments," little kids, and keeping things organized. And even then, she was a romantic at heart—although she knew that the career she was working so hard to pursue could end up getting in the way of her happily ever after. "I've never been the kind of girl who needs a boyfriend. Plus, guys don't ask me out because they know I'll write a song about them. But I'm also the girl who still believes Prince Charming exists out there—fully equipped with great hair and an immature sense of humor."

Well, that explains Joe Jonas.

And even then, she was sure to mention that she loved her fans. "You are absolutely wonderful to me. I've got your back, just like you've had mine. To anyone who has gone out and bought my CD, or come to a show, or even turned my song up when it came on the radio, all I can say is thank you," she wrote.

Some twenty years later, it seems safe to say that she still feels that way.

Once Taylor figured out how to find her fans, she launched a website that would allow us to find one another. It was called Taylor Connect, and it was basically a giant forum for her fans to meet and talk about her music and plan to meet up at concerts—all of the stuff we now do on apps like Instagram or TikTok or Reddit. If you weren't lucky enough to use it back then, think about what it would be like if Taylor Nation's social media accounts were an online message board. Taylor Connect also worked to give fans more access to Taylor, whether that was through registering for meet-and-greet passes (yes, it used to be *that* easy) or, during the *Red* tour, entering for the chance to purchase pit tickets for a cool $150 each. Can we have those prices back, please?

The website shut down at the end of 2017, before the launch of the Swift Life app, which was meant to replace Taylor Connect with new features, like Taymojis (emojis that looked like Taylor, of course). But Swift Life didn't end up taking off the way Taylor and her team had hoped, and in February 2019, the app was discontinued. Fortunately, fans proved we didn't need a dedicated app to continue connecting to one another (and sleuthing together) anyway.

SAM, SAM, SAM, SAM, SAM, SAM

It may have only been since 2017 that Taylor truly became famous for dropping clues about her music in her social media posts and music videos, but she's been training us to be on our Olivia Benson shit from the very beginning. It started with her debut album, and if you were a fan back then, there's a really good chance that you owned the physical album; after all, at that point, we all still used CD players (and probably iPods). Taylor's album liners were where she hid her Easter eggs at first, leaving secret messages for fans to decode in the lyrics to her songs. At first glance, it just looked like random letters were capitalized through the lyrics, but if you took those capital letters out, they created a message about each song.

The letters scattered through "Should've Said No" spelled out "Sam, Sam, Sam, Sam, Sam, Sam"—the name of a high school boyfriend who had cheated on her. And the letters in "Tim McGraw" spelled out "Can't Tell Me Nothin'," or the title of one of the country legend's songs.

> "I'm also thinking about the secret codes to put into the lyrics, like with the last album. I think it'll be the same code system, where all the letters of the lyrics are lowercased except for some. You put the capitalized letters together and it spells out a phrase or word. It was cool to have that on the first record. I got to call out a few guys, which is always fun for me. Love that."

Taylor talked about the messages (or as she calls them, secret codes) in a Myspace blog she posted in August 2008, when she was planning out the album liner for *Fearless*.

"I'm also thinking about the secret codes to put into the lyrics, like with the last album. I think it'll be the same code system, where all the letters of the lyrics are lowercased except for some. You put the capitalized letters together and it spells out a phrase or word. It was cool to have that on the first record. I got to call out a few guys, which is always fun for me. Love that."

She continued this tradition all the way through *1989*, but her secret codes were

TAYLOR'S FIRST FAN

There are a lot of fans who have been with Taylor since the beginning, but who was there first? That title might just belong to Holly Armstrong, who first saw Taylor perform on July 23, 2003, at Jenkinson's Boardwalk in Point Pleasant, New Jersey—three years before Taylor would release her debut album. After a photo of Taylor and Holly that was taken that day went viral in 2019, fans seemed to agree that she was the very first Swiftie. And while Holly says her memory of that day more than two decades ago is a bit fuzzy, what she does remember is Taylor's confidence.

"I'd never connected with an artist in that way—primarily because most country artists were singing about life experiences I was too young to appreciate," says Holly. "I don't recall exactly what songs she performed, aside from 'Lucky You' and, if my family's account is correct, 'Smokey Black Nights.' However, that was enough for me to fall in love with her art."

Holly met Taylor after the show, and she was struck by her "understanding, kindness, and gratitude"—even though Taylor would have only been thirteen years old at the time. She walked away with a photo, an autograph, and Taylor's demo CD.

"I listened to the songs on the demo CD in the car on the way to school, at my birthday parties, and in moments when I was utterly alone," Holly says. "Her music had become something of a companion for me when life got really difficult, as it does for so many now. For that, and many other things, I am eternally grateful to Taylor, and it's my deepest honor to support and cheer her on through the eras of our lives."

missing in the *Reputation* album liner and were never seen again. By then, she found new ways to give fans the chance to play Nancy Drew (but more on that later).

The key to a lot of the Easter eggs that Taylor hides today is the number thirteen, which is her lucky number—and she has plenty of evidence to prove it. As she told MTV News in 2009, "I was born on the thirteenth. I turned thirteen on Friday the thirteenth. My first album went gold in thirteen weeks. My first number 1 song had a thirteen-second intro. Every time I've won an award, I've been seated in either the thirteenth seat, the thirteenth row, the thirteenth section, or row M, which is the thirteenth letter."

It's hard to argue with solid logic like that, and the pattern of this typically unlucky number woven through her career means that, as fans, we are always looking for thirteens, too—and when we see one, we know that it is never a coincidence.

THE HIGHLIGHT OF HER SENIOR YEAR

Most people didn't know who Taylor was when her debut album was released, but it didn't take long for her fame to take off. Our girl loves to win an award, and it all started on album one. She scooped up all kinds of nominations for *Taylor Swift*, including her very first Grammy nod: Best New Artist.

But there was one award that appeared to be the most meaningful to her: the Horizon Award at the Country Music Association Awards, which honored new artists in the genre.

If it still makes you cry nearly two decades later to watch baby Taylor get on that stage, you're not the only one, because I'm getting emotional just thinking about it. Between the look on her face as she heard presenter Carrie Underwood say her name, sitting next to her mom, Andrea Swift, in the audience, and how she didn't even try to hold back her tears during her acceptance speech, it was striking how authentic she was in a way that only a teenager accepting a major award could possibly be.

"This is definitely the highlight of my senior year," she said.

She had a lot more to celebrate than just the Horizon Award (though that was, obviously, a really big deal). *Taylor Swift* debuted at number 19 on the Billboard 200 chart after selling forty thousand copies in its first week, and as more

people discovered her music, sales continued to grow. A little over a year later, more than one million copies had been sold, and in January 2008, the album peaked at number 5. Her debut album's 157 weeks on the Billboard 200 chart also made it the longest-charting album of the decade.

> "I said in an interview 13 years ago, 'I'm just hoping that I have a second album that does as well as the first and someday get to be a headliner, and always be the same person that I started out as.' Scrolling through your posts today has me feeling all the feelings & I want to thank you. Because of you, there was a 2nd 3rd 4th 5th 6th and 7th album."

When it comes to reviews, on the other hand, her debut wasn't getting anywhere close to the love from critics that she'd get years later for albums like *Red* and *Folklore*, but even back then, critics all seemed to zero in on Taylor's true strength: the honesty in her lyrics.

In October 2019, Taylor marked the album's thirteenth anniversary with an Instagram post to thank her fans for all their support in the intervening years.

"I said in an interview 13 years ago, 'I'm just hoping that I have a second album that does as well as the first and someday get to be a headliner, and always be the same person that I started out as.' Scrolling through your posts today has me feeling all the feelings & I want to thank you. Because of you, there was a 2nd 3rd 4th 5th 6th and 7th album. You guys made me into a headliner because you wanted to see me play. And your support all these years is what's helped me stay true to that kid I was when I started out."

HOW TO SPOT A SWIFTIE IN THE WILD

When you're at a Taylor Swift concert—or, you know, in any given Starbucks location in the US, especially during *Red (Taylor's Version)*'s release week—it's easy to spot a fellow Swiftie. But when you're out in the rest of the world, it's not always that easy. Taylor fans are everywhere, of course, since she is one of the most popular music artists of our time, but there are levels to this fandom. There are the fans who know all her lyrics and bought a T-shirt at the Eras Tour, and then there are the fans who know what Calcium Hydroxide means. Both types of fans are valid, but they are not the same.

So how do you know somebody isn't going to look at you like you have three heads when you launch into theories about what the blue and black fingernails beside a coffee cup in the "Karma" music video *really* mean? There will probably be a few clues...

A TATTOO

(Sometimes known as a Taytoo): It might be the word *fearless* inked on the inside of someone's wrist, the number 13, or line art of a mirrorball—you'll know it when you see it.

A CARDIGAN

Not just one from Old Navy—it has to be one of *the* cardigans, whether it's the OG from *Folklore* or even the purple *Speak Now (Taylor's Version)* edition. This is the easiest sign to look for.

MERCH

Aside from the cardigan, it's easy to spot merch from Taylor's online store. Bonus points if you see a blue crew neck.

BRAIDED HAIR

A subtle sign, for sure, but it still counts—whether it's a French braid that's giving *Evermore* or braided pigtail buns like *Folklore*.

A SNAKE RING

This means you've come across a *Rep* stan—that's a real one.

FRIENDSHIP BRACELETS

Ideally with lyrics or song titles on them, just to be sure.

AN IRIDESCENT, SQUARE IPHONE CASE

Just like Taylor's. If it's good enough for her, it's good enough for us.

FEARLESS

THE HAND HEART ERA

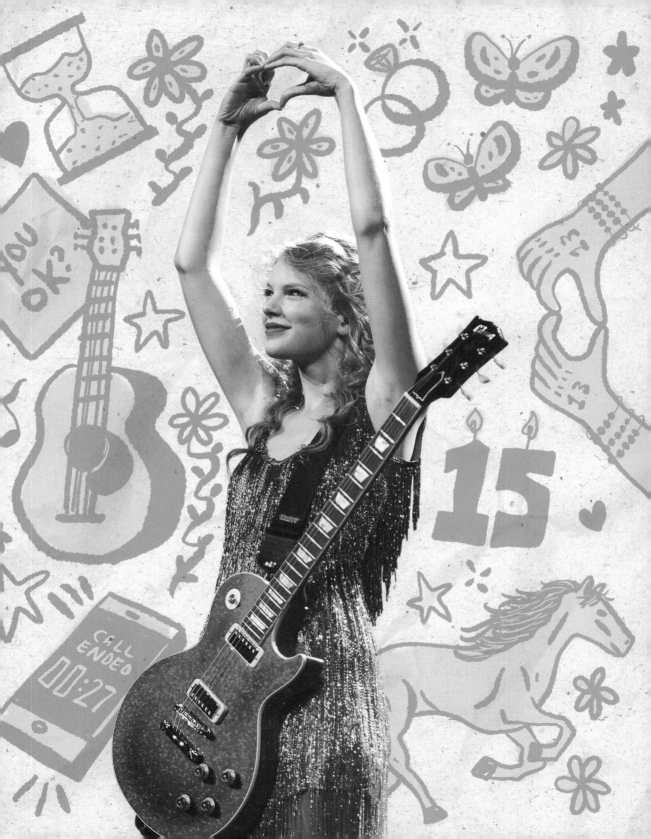

By the time Taylor Swift released her second album, I was nineteen years old and getting my earliest tastes of freedom as I stumbled into my second year of college, a time in my life when I quite literally did not know what I was doing. The good news? Neither did anyone else my age, including Taylor Swift. This is the era where I would meet her for the very first time, now officially and completely sucked into the fandom. Along the way, I also made my first Swiftie friendships, which have turned into some of the longest lasting, closest of my life.

HAVING FEARS
BUT JUMPING ANYWAY

By the time *Fearless* was released on November 11, 2008, there were already a few symbols that fans associated with Taylor, like cowboy boots, sundresses, curly blond hair, and the number thirteen. But what her second album gave us was a word: *fearless*.

It wasn't just an album title; it was a philosophy. Fans tattooed it on their bodies, and they took Taylor's definition of the word to heart. The prologue to the album included in the liner notes has always been something that fans look forward to reading, and the power behind the *Fearless* prologue might be what started it all. It was there that she shared her own interpretation of what being fearless really means.

"To me, 'Fearless' is not the absence of fear. It's not being completely unafraid. To me, fearless is having fears. Fearless is having doubts. Lots of them. To me, fearless is living in spite of those things that scare you to death. Fearless is falling madly in love again, even though you've been hurt before. Fearless is walking into your freshman year of high school at fifteen. Fearless is getting back up and fighting for what you want over and over again . . . even though every time you've tried before, you've lost. It's fearless to have faith that someday, things will change. Fearless is having the courage to say goodbye to someone who only hurts you, even if you can't breathe without them. I think it's fearless to fall for your best friend, even though he's in love with someone else. And when someone apologizes to you enough times for things they'll never stop doing, I think it's

fearless to stop believing them. It's fearless to say 'you're NOT sorry,' and walk away. I think loving someone despite what people think is fearless. I think allowing yourself to cry on the bathroom floor is fearless. Letting go is fearless. Then, moving on and being alright . . . that's fearless, too. But no matter what love throws at you, you have to believe in it. You have to believe in love stories and prince charmings and happily ever after. That's why I write these songs. Because I think love is fearless."

While her debut album was a hit, *Fearless* showed what she could really do. The first hints of her eventual pop crossover were heard in this album, and everything about it was stronger. Now that Taylor was a couple years older and had a bit more experience in the music industry, she was able to bring so much more depth without losing her sincerity. Reviews of *Fearless* at the time showed that critics noticed her growth, too. *Rolling Stone* called her a "songwriting savant with an intuitive gift for verse-chorus-bridge architecture," later pointing out that her lyrics include "squirmingly intimate and true" confessions about what it's really like to be a teenage girl.

Looking back, it's kind of wild to think that it was only her sophomore album that won Taylor her first Album of the Year award at the Grammys, but *Fearless*

features the songs that more casual fans think of first when they hear her name. "You Belong With Me" and "Love Story" were (and still are) so huge that it's hard to believe she pulled off both those hits at such an early stage.

Album of the Year wasn't the only Grammy that *Fearless* was up for. Taylor secured a whopping eight nominations that year (second only to Beyoncé's ten). And when she won Entertainer of the Year at the CMA Awards one year after the album's release, her acceptance speech there also secured her place as a celebrity who is going to make people cry *every* time she accepts an award. Standing up on that stage, twenty years old, and absolutely covered in sparkles, Taylor almost couldn't hold it together as she said, "I will never forget this moment, because in this moment, everything that I've ever wanted has just happened to me."

With her new level of confidence, she started trying different things, like guest starring on the television show *CSI*, producing her album, and launching her own line of sundresses at Walmart. She entered her twenties, she moved into her own apartment in Nashville (complete with an indoor koi pond), and she was officially a grown-up.

But even being an adult didn't keep her from embracing all things

fairy-tale—a theme that would end up following her well into the *Speak Now* era. The "Love Story" music video was filmed in an actual castle, after all. And at the same time, she was giving her fans permission to believe in happy endings and have fun with those fairy-tale ideals, even as they got older, too.

> "To me, 'Fearless' is not the absence of fear. It's not being completely unafraid. To me, fearless is having fears. Fearless is having doubts. Lots of them. To me, fearless is living in spite of those things that scare you to death."

WE'RE ALL CONNECTED SOMEHOW

By the time *Fearless* was released, Taylor found new ways to connect with her growing number of fans, and one of those was through the vlogs she shared on YouTube. The videos were cool to watch then, but they're even more fascinating to go back and watch now (and they all still live on Taylor's official YouTube channel). She edited the videos herself, set to songs that were popular toward the end of the 2000s, like "Hot N Cold" by Katy Perry and "Sugar, We're Goin' Down" by Fall Out Boy. Music that she loved was music that we all loved, and seeing her interact with her friends and bandmates was like watching anyone interact with their friends.

While fans know this, the casual listener (and Jake Gyllenhaal, apparently) might not, so it needs to be said anyway: Taylor is *funny*. She was funny then, and she's funny now—and that's helped by the fact that she has never been afraid to make fun of herself and she has never taken herself too seriously. Right now, you can go to Taylor's YouTube channel and watch one of her very prestigious music videos *or* you can watch a fifty-eight-second clip from November 2008 where she's getting her retainer replaced after she left it in a hotel room.

Some of these videos were posted to encourage her subscribers to participate in fan-voted awards or to remind people to purchase her album, but most of them were shared for the sake

of sharing what her daily life looked like with her fans. The way that Taylor has kept her loyal followers at the center of it all has never changed.

In a Myspace blog she posted in November 2008, Taylor wrote, "Usually when life is happening to you, you feel like you're the only one going through it. When I finish a song, sometimes I think 'I must be the only person who has ever felt this way, right?' Then you guys come into the picture. You stand there, singing those lyrics and writing them all over your car windows and your shirt and your away messages. And I want you to know that it makes me so happy, because it's reassurance that we're all connected somehow."

Being a Swiftie has never felt like a one-sided relationship, but this was especially true during this part of Taylor's career. She seemed to be getting as much comfort and connection from us as we were from her and her music.

She also had a goal of meeting as many of us as possible, and she got a little closer to making that happen at a thirteen-hour meet and greet at CMA Fest in Nashville on June 13, 2010. As we learned in her *Taylor Swift Now* series, which was part of a partnership with AT&T in 2016, this was entirely Taylor's idea. She rented out Bridgestone Arena—one of the biggest venues in the area—with the plan to meet fans for thirteen hours. In a row.

It would be impossible to emphasize enough how much this kind of thing simply does not happen. Sure, there are fan-friendly celebrities out there who are happy to stop when they're recognized in public. There are stars who attend conventions to meet those who feel a connection to their work, and plenty of musical artists have held meet and greets, both paid and free, while out on tour. This was a remarkable, once-in-a-lifetime event for Taylor and her fans.

It also wasn't just a meet and greet. The area was filled with set pieces and costumes from her *Fearless* tour, and her tour bus was parked inside the building so fans were able to walk through and see where Taylor lived when she was on the road. And in the middle of the day, Taylor took a break to perform a short set for the fans who had gathered there.

Best of all? It was totally free.

More than two thousand people lined up outside the arena to meet Taylor, and while that doesn't sound like much compared to the crowds she'd command many years later, back then, it was a big deal. And out of all of those people, I was one of the first in line. I was twenty-one at the time, and while spending the night camped out on a sidewalk in downtown Nashville doesn't sound appealing at all anymore, it felt like the best idea ever then. My friends and I brought sleeping

How to Dress
for the
FEARLESS
Era

ANYTHING WITH GOLD OR SILVER FRINGE

ROMANTIC, RUFFLY DRESSES

BLUE NUMBER 13 ON YOUR HAND

SPARKLY DRESS

HOMEMADE JUNIOR JEWELS T-SHIRT AND PAJAMA PANTS

bags and staked our spots around dinner-time the night before the meet and greet was scheduled to happen. It was summer in the South, which meant it was a sweaty experience. Just before the sun came up, I crossed the street and went into a hotel bathroom, where I washed my hair in the sink and plugged in the blow dryer I'd brought with me. And when that was over, I whipped my curling iron out of my backpack and changed into a dress and applied my makeup while it was heating up. An hour later, I was ready . . . and back in line just in time to snag the wristband I'd earned after proving my loyalty. But fortunately, I no longer looked like I had slept outside to get it.

This was *the* moment. This was Taylor Swift. This would be the photo that would become my profile picture across all my social media, in perpetuity. I could not take any risks.

And this was the story I told when Taylor and I came face-to-face a few hours later. Of all the things that I could have (and wanted to) say to her—about how much her music had impacted me, the tough times that her words had gotten me through, how she absolutely *had* to record "Sparks Fly" for her next album because I was tired of listening to that live recording I downloaded on Lime-wire—instead, I totally blacked out and blurted out the details of my morning.

It all came out as one word: "Ididmy-hairandmakeupintheHiltonbathroom."

She didn't look at me like I was weird. She didn't even look confused. Instead, she laughed and gave me a hug and said, "Really? Look at how beauti-ful you are!"

She asked how long I had been wait-ing, and when I told her, she jumped up and down in excitement and hugged me again.

I believe there's truth behind the saying "Never meet your heroes." I've learned that the hard way through many years of entertainment reporting (and even just being a fan of all things celeb-rity before that).

But with Taylor, it's absolutely not true. Taylor Swift is exactly who you think she is: a warm, excitable person who has a way of making you feel like you're her best friend, even though you're total strangers who just met. It's been well over a decade since that short conversa-tion, and I still carry it with me. When I'm looking in the mirror and I'm just not feeling myself, when I'm struggling with the ways my body has changed after pregnancy and becoming a mom, her voice pops into my head: "Look at how beautiful you are."

When Taylor Swift speaks to you, it's easy to believe her—after all, she's been telling the truth in her music all along.

To ensure that everyone who showed up that day left happy, the thirteen-hour meet and greet lasted longer than planned. By the time she left the building, she had been there for nearly fifteen hours, taking photos, signing autographs, and performing an acoustic set.

Nothing like this has happened since, and there's a good chance that nothing like this will happen ever again. Somehow, Taylor managed to take advantage of that one window of her career where she had the space to give her fans that dedicated in-person time, as fleeting as it might have been.

THE FEARLESS TOUR

The release of Taylor's second album also gave her the opportunity to embark on her first world tour, which was also her first headlining tour. While promoting her debut album, she'd mostly done so as an opening act, warming up the crowd before artists like Keith Urban or Rascal Flatts would take the stage. But the *Fearless* tour was *her* tour, and she threw herself into it.

Between April 23, 2009, and July 10, 2010, Taylor made 188 tour stops in North America, the UK, Australia, and Japan. While the competition for tickets was *nothing* like it was for the Eras Tour (and neither were the prices), it was still a challenge. Taylor's fan base was growing quickly, and tickets for every show on the tour sold out within minutes of going on sale.

Before the first date of the tour, Taylor gave fans an update on the dancers and musicians who would be joining her on the road—and that her band had started calling themselves The Agency because "they got to dress up in suits and sunglasses and ransack a house in the 'Picture to Burn' video" like secret agents. At the time, The Agency included Grant Mickelson, Paul Sidoti, Al Wilson, Caitlin Evanson, Mike Meadows, Amos Heller, and Liz Hewitt. As a testament to the strength of Taylor's relationship with her band from the beginning, some of those very same musicians joined her for the Eras Tour, too, including Paul, Amos, and Mike.

Taylor was very hands-on for this tour, which won't surprise her longtime fans; it's always been important to her to be involved in every part of her career. As she explained in her *Journey to Fearless* docuseries that followed the making of the tour, she helped design the stage

herself, which was built in a warehouse in Nashville, and was on hand to help out with an open-call audition for dancers who would join the tour.

"I had always wanted to put together a show that incorporated theater and storytelling and songwriting—what I saw in my head when I was writing these songs," she said.

She certainly seemed to have succeeded, even when it came to the bumper videos that played on-screen when she wasn't on the stage. In one clip, she brought friends and fellow celebrities to collaborate for a sketch called *Crimes of Passion*, a mock crime show that interviewed the men who had the unfortunate experience of becoming the subject of Taylor's songs. Even from the beginning, Taylor has been in on the joke, whether or not her critics have chosen to see it.

In the documentary, she said that the part of the concert where she got to walk through the crowd was one of her favorite moments of the evening, since it allowed her to interact with her fans (even if she was being followed by security the whole way).

"It was really important for me to go out there and actually say hi to people and thank them for coming and be right next to them," she said. "I'm always

gonna want to go the extra mile for them because I can't believe the extra thousand miles they've gone for me."

The tour also brought other opportunities for fans to meet Taylor. A new tradition began during the *Fearless* tour: before and during each concert, members of Taylor's team (including her mom, Andrea Swift, who fans have nicknamed Mama Swift) would scour the crowds, looking for fans to invite to a backstage meet and greet. It didn't matter where you were sitting—if you were in the nosebleeds or if you had floor seats—if you looked like you were having fun and fully engaged in the show, you had a chance of being spotted. The whole family was involved with helping fans feel closer to Taylor, with Andrea offering tours of the backstage area before the concert and her dad, Scott Swift, beginning his time-honored tradition of handing out guitar picks to fans (something he still does today).

Every night, the concert ended with an especially memorable moment: Taylor, complete with special effects that made it look like she was standing in the pouring rain, singing "Should've Said No." She's always said that she loves a rain show, and that love might have started with the *Fearless* tour.

THE TWENTY-SEVEN-SECOND BREAKUP

In one video that played on the screen each night of the *Fearless* tour, Taylor says, "If guys don't want me to write bad songs about them, then they shouldn't do bad things."

The guys who learned this hard way on most of her debut album and on *Fearless* were ones who lived their lives out of the spotlight—mostly who Taylor had known from high school. For instance, there was Drew, who was obviously the reason for the teardrops on her guitar, and Cory, who smiles like the radio in "Stay Beautiful" (has anyone figured out what that's supposed to mean yet?).

But *Fearless* introduced us to the first celebrity boyfriend who would evoke strong feelings from the fandom: Joe Jonas. When he and Taylor crossed paths for the first time in the summer of 2008, the Jonas Brothers were at their peak, and Taylor's star was on the rise. Considering the fact that back then (and even today), the Venn diagram of Taylor Swift fans and Jonas Brothers fans looked a lot more like a circle, it's impossible to overemphasize what a big deal this was. Taylor was *dating a Jonas Brother.*

Since their relationship lasted for just a matter of months, Taylor and Joe were only seen in public together a couple times. Taylor performed with the brothers during their Burnin' Up tour, which would end up being featured in their 3D concert movie, and the couple attended the MTV Video Music Awards together in September 2008.

But by the time fall was in full swing, it was over—and Taylor wasn't shy about talking about it. She added the song "Forever & Always" to *Fearless* at the last minute, telling Ellen DeGeneres about what went down in an interview on her show. After Ellen put up a photo of Joe Jonas on-screen, a then-eighteen-year-old Taylor admitted, "That guy's not in my life anymore, unfortunately," calling their breakup an "ouch." But she didn't stop there. It was then that Taylor revealed exactly *how* Joe had ended things with her—something that her fans would never forget. And they wouldn't let Joe forget it, either—especially when *Fearless (Taylor's Version)* came out in 2021. Goodbye, Mr. Perfectly Fine!

"When I find that person that is right for me . . . he'll be wonderful. And when I look at *that* person, I'm not even gonna be able to remember the boy who broke up with me over the phone in twenty-five seconds when I was eighteen,"

HOW TO KNOW YOU'RE A SENIOR SWIFTIE

The image of screaming teenage girls making up Taylor's dedicated fan base is wildly outdated. Nearly two decades after Taylor released her debut album, her fandom spans generations, from Taylor Tots who were born to Swiftie moms to fans who were born long before *1989*—the actual year *and* the album. That's part of what makes her music so magical: the themes she sings about are universal, and anyone can relate.

If you've been around the fandom for a while, you've probably heard the term Senior Swiftie, and while some take it to mean anyone over the tender age of twenty-five, it usually means that you're a grown-up fan who's been around since roughly before the *Reputation* era (but usually much, much earlier). Being able to claim the title of Senior Swiftie is actually a badge of honor—you were right about Taylor all along and have stuck by her through thick and thin. So how do you know you're a Senior Swiftie? If any of the following applies to you, this is a title you can claim proudly:

You know what it's like to spend big-girl money on a merch drop but probably still regret it the next day.

· · · · · · · · · ·

You've used the Swift Life app, and you definitely had an account on Taylor Connect.

· · · · · · · · · ·

You listened to Taylor's music on an iPod, including the live recordings of songs that never made the final album cut.

· · · · · · · · · ·

You actually owned an iPod.

· · · · · · · · · ·

You knew Jack Antonoff as the guy from the band fun.—before you knew him as Taylor's friend and collaborator.

· · · · · · · · · ·

There's a leather "love love love" bracelet somewhere at the bottom of your dresser drawer (though, by now you've already forgotten how to tie it).

You took photos at your first Taylor concert with a digital camera.

And you didn't share them on Instagram, because there was no Instagram.

But you did upload at least seventy-five photos you took that night onto Facebook, including the blurry ones … and you probably titled the album something like "I don't know how it gets better than this."

· · · · · · · · · ·

You own a bottle of Taylor's discontinued perfume, Wonderstruck, but only use it on special occasions so you won't run out.

· · · · · · · · · ·

You remember when Taylor spoke (and sang) in a southern accent, and you're still wondering what that was about.

· · · · · · · · · ·

she said. (For the record, when Joe responded, he noted that the phone call was *actually* twenty-seven seconds long, since it could "only last as long as the person on the other end of the line is willing to talk.")

Along with making her feelings known in the lyrics of "Forever & Always," Taylor would continue to reference the breakup, including in one vlog where she was holding a *Camp Rock* Joe Jonas doll, saying, "This one even comes with a phone, so he can break up with other dolls." And then there was the shout-out he probably wished he didn't get in Taylor's *Saturday Night Live* monologue song a year later: "You might think I'd bring up Joe / The guy who broke up with me on the phone / But I'm not going to mention him / In my monologue / Hey, Joe! I'm doing real well / Tonight. I'm hosting *SNL* / But I'm not going to brag about that / In my monologue."

This particular version of spicy, vengeful Taylor wouldn't last, but while it did, she was a lot of fun, wasn't she?

Joe and Taylor would eventually become friends, and Taylor *did* get something pretty sweet out of that split: her friendship with Selena Gomez, whom she met while they were both dating one of the brothers (for Selena, that was Nick). Years later, when she and Joe buried the hatchet, she'd also form a friendship with his ex-wife, actor Sophie Turner—a bond that ended up outlasting their marriage.

During the *Fearless* era, Taylor would also date Taylor Lautner, who was flying high off of the hype that the *Twilight* movies brought him. They met on the set of the film *Valentine's Day*, where they played a couple, and art quickly became life. Their relationship didn't last longer than a few months, but he would end up being present for what would turn out to be one of the most defining moments of our Taylor's career.

LIFE IS FULL OF LITTLE INTERRUPTIONS

September 13, 2009: the night that Taylor Swift would win Best Female Video at the MTV VMAs. Arguably a less-prestigious award than the Grammys she would go on to win a few months later, but this is the one that had the bigger impact— and of course this happened on the thirteenth day of the month.

When Taylor took the stage to accept the Moonman that her then-boyfriend

Taylor Lautner was presenting, she was famously interrupted by Kanye West, now known as Ye. As soon as the words "I'mma let you finish" were out of his mouth, nothing was ever the same.

I can still remember watching that moment as it unfolded live, having tuned in to the VMAs specifically for Taylor. I can also remember the look on her face when Kanye appeared next to her onstage, and how quickly she handed the microphone over to him—a man and an artist who was more than a decade older and more experienced than she was, one she mentioned she was a fan of—to steal her spotlight. I'm fairly certain the Taylor we know today would have had a very different reaction if that happened to her, but that nineteen-year-old girl looked so lost.

What else sticks out from that night is how Beyoncé reacted to Kanye telling the audience that she should have won the award instead of Taylor, shaking her head in embarrassment. And when Beyoncé *did* win a well-deserved award later that night, she called Taylor onstage to let her speak instead. These powerful women have had each other's backs ever since, even when fans have tried to pit them against each other. They even showed up for each other's concert movie premieres fourteen years after this unfortunate incident, further tying them together.

But back to that fateful VMAs night in 2009. Taylor next performed "You Belong With Me" as planned, right after her win was so rudely undermined—even though a lot of people in her situation likely wouldn't have stayed. Looking back at that night during an interview with *GQ* in 2015, Taylor admitted that it wasn't just that she'd been interrupted that had upset her; she thought the crowd was booing *her*, not Kanye. "When the crowd started booing, I thought they were booing because they also believed I didn't deserve the award," she said. "That's where the hurt came from. I went backstage and cried, and then I had to stop crying and perform five minutes later. I just told myself I had to perform, and I tried to convince myself that maybe this wasn't that big of a deal."

To Taylor, the idea of being booed by the crowd—which wasn't just made up of fellow artists, but also fans—really *would* have been a big deal. Even though this was still early in her career, she had already invested so much in building that connection to fans, and their love was something she clearly valued. At first, it must have felt like a betrayal not just by Kanye, but by fans she felt had her back, and in that moment onstage, she didn't know how things would shake out.

Even outside the Taylor Swift bubble, this one moment had a massive impact

during a time when pop culture moments going viral on the internet was still a relatively new phenomenon. Twitter, now known as X, was in its earliest years, so live tweeting events like award shows as everyone experienced them in real time in this way was a concept still in its infancy. The reaction that the VMAs incident got offline was unprecedented, too. The sitting president at the time, Barack Obama, even commented about it during an off-the-record portion of an interview with CNBC, calling Kanye a "jackass" in the process. So in a lot of ways, Taylor was right: This was a big deal.

The incident between Taylor Swift and Kanye West didn't end at the VMAs that night. It would come back in the form of the song "Innocent" from *Speak Now*, when Taylor addressed what happened in the way she processes all the big milestones in her life. And when she decided to disappear as the *1989* era came to a close, Kanye would be a big piece of that decision, too. As the feud continued between Kanye, Taylor, and eventually Kanye's then-wife, Kim Kardashian, we'd hear echoes of their conflict through her other music, too.

When reporter Judy Rosen visited Taylor's Nashville apartment to interview her for a profile published in *New York Magazine* in 2013, Kanye was there, too. A photo of the moment he interrupted Taylor onstage was framed on a wall of Taylor's living room, featuring a caption in Taylor's handwriting that said, *Life is full of little interruptions.*

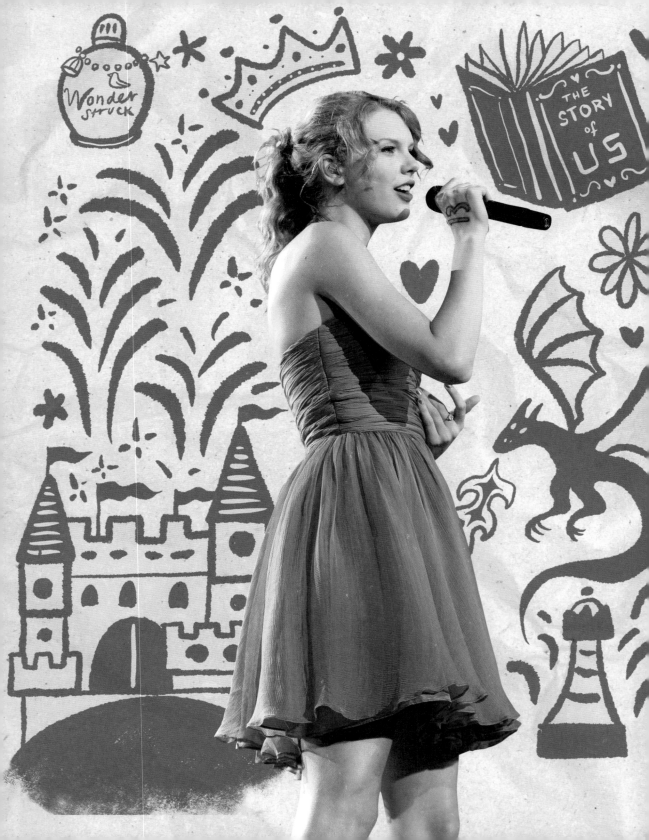

Speak Now

THE ENCHANTED ERA

When *Speak Now* came out in 2010, I was going to college and working full time as a receptionist at a dry-cleaning service, saving up money to make my big move to New York, where I was obviously going to become editor-in-chief of *Seventeen* (okay, not right away, but that's how it was all going to start). Of course, I did use some of that money to road-trip to Nashville with my BFF so we could meet Taylor at one of the launch events for her new perfume, Wonderstruck. You know, during a time when buying a deluxe perfume gift set got you a pass to meet Taylor Swift.

I DON'T THINK YOU SHOULD WAIT— I THINK YOU SHOULD SPEAK NOW

So much of what has contributed to Taylor's massive success—and what makes being a Swiftie so interesting—is the fact that she is constantly evolving without ever compromising who she is. For example: debut Taylor and *Reputation* Taylor are both so different, but both eras (and the music that came from them) feel authentic to who she was at the time. The Taylor we know and love in the 2020s is *so* different from the Taylor we've been talking about so far, but *Speak Now* Taylor is the version of her where you can most easily see glimmers of the superstar she would grow to become.

It was almost as if surviving the VMAs incident, winning multiple Grammys, and coming off of a sold-out world tour is what gave Taylor the confidence to level up (imagine that), and the change in her was clear to see as soon as the *Speak Now* era began, starting with the album announcement. This was the first time she live streamed the reveal of her album (and its cover) on a website called UStream, which doesn't even exist today, and it was *nothing* like TikTok. (A recording of that stream still lives on YouTube today, and it's kind of wild how she just shares all the details about her album up front without making anybody solve puzzles or delve into website code first. A simpler time, even if it was a little less fun.)

Even though I was able to watch live, I had friends who couldn't, and I can remember sitting in front of my computer, taking notes with a pen and paper so everyone who was missing out would know the latest news. Back then,

35

high-quality recordings of live streams didn't immediately appear online after the stream ended, so this is how we had to do things. It was a lot of fun this way, though—kind of like how you feel when you wake up and find TikTok videos waiting for you in the group chat that your friends sent of the Eras Tour from the night before.

On the stream, Taylor answered fan questions and, most importantly, revealed very big news: *Speak Now*, her third studio album, was coming out on October 25, 2010. This is also when she shared that she had written this album entirely by herself. In the live stream, Taylor said that happened by coincidence, since she was writing while on the *Fearless* tour and didn't have many other musicians around to collaborate with, but later, she'd admit that there was a bit more to it than that. "I've had several upheavals in my career. When I was eighteen, they were like, 'She doesn't really write those songs.' So my third album I wrote by myself as a reaction to that," she told *Rolling Stone* in 2019.

One of the songs on the album that she might have been thinking of during that interview was "Mean," which was written in response to her critics, and many speculated that it might be about one in particular: Bob Lefsetz. In his newsletter, he very confidently declared that "everybody knows that Taylor Swift can't sing"

after she performed with Stevie Nicks at the Grammys in 2010. He wrote: "Taylor Swift shortened her career last night. And since she says she calls all her own shots, she has to shoulder the blame. Yes, her dream came true, she made it, she's a star, but the real test is longevity. Elton John can play with Gaga decades later. Will Taylor Swift be duetting with the stars of the 2030s? Doubtful."

While Taylor's future is obviously yet to be determined, not only is it likely that she'll be duetting with the stars of the 2030s, but it's even more likely that she will *be* a star of the 2030s. Knowing this—and after hearing "Mean" and the rumors that Lefsetz inspired it—you'd think that Bob would have eaten his own words by now, but you'd wrong. Because in *another* edition of his newsletter that was published in 2023, he only doubled down.

Remember when I talked about those people who are missing out on Taylor? Unfortunately, Bob here is one of them. But once Taylor got whatever feelings she might have had toward this critic out of her system with "Mean," she moved on, and it's a very good thing she did.

Relying on her own experiences and songwriting talent despite the criticism she'd received ended up being one of the smartest decisions that Taylor ever made. *Speak Now* sold over one million copies in its first week, making Taylor

the first female artist to do so in the six years since Norah Jones achieved the milestone with her album *Feels Like Home* in 2004. Taylor was sharing her feelings, her heartbreaks, and even the experience of moving out of her parents' house and living on her own for the first time, and millions of people around the world were listening.

> "What you say might be too much for some people. Maybe it will come out all wrong and you'll stutter and you'll walk away embarrassed, wincing as you play it all back in your head. But I think the words you stop yourself from saying are the ones that will haunt you the longest."

The concept of *Speak Now* as an album sums up so much of what keeps fans coming back to buy album after album, no matter how many times Taylor switches up her style or genre of music or aesthetic. Whether it's snakes or fairy-tale castles or cozy cardigans, when Taylor is writing a song, she is speaking up and telling the truth in a way that feels real to people all over the world.

This era of her career was when Taylor seemed to fully grasp what it meant to be able to express her feelings in a way that anyone could relate to while also being one of the only artists during this time to treat the audience she was singing to—young adults, mostly women, in their teens and early twenties—as if their feelings were important (because they were, and still are).

Being caught in that weird, in-between time when you want to be seen as an adult but you don't know how to be one, or as the great Britney Spears once put it, "not a girl, not yet a woman," is fun and exciting and scary, and filled with big emotions that some people don't take seriously. But not only did Taylor take them seriously as she wore her own big feelings on her sleeve in such a raw way, but she also convinced the world, in some part, to do the same.

This era was when Taylor discovered that her real superpower was making people feel seen, and she knew it when she wrote the prologue to the original version of the album.

"What you say might be too much for some people. Maybe it will come out all wrong and you'll stutter and you'll walk away embarrassed, wincing as you play it all back in your head. But I think the words you stop yourself from saying are the ones that will haunt you the longest. So say it to them. Or say it to yourself in the mirror. Say it in a letter you'll never send or in a book millions might read someday. I think you deserve to look back on your life without a chorus of resounding voices saying 'I could've, but it's too late now.'"

THE *SPEAK NOW* WORLD TOUR

The *Fearless* tour may have been considered a success, but the one for *Speak Now* ended up blowing it out of the water. After performing 118 shows, the *Fearless* tour brought in $66.5 million, but *Speak Now* brought in double that amount at $123.7 million across eight fewer shows. This time around, Taylor was playing bigger venues, and she was also approaching the tour as more of a businesswoman, fully emboldened to shape Taylor Swift the brand into exactly what she wanted it to be.

Along with this tour came some major partnerships. Not only did Taylor release her first perfume, Wonderstruck, with Elizabeth Arden in the middle of the tour, but she was also the face of Cover-Girl. Since CoverGirl sponsored the tour, they partnered with Taylor to allow fans to use codes from the brand's products to earn points that could then be used to purchase tickets—it sounds unbelievable to hear that now, but it's true. Nothing like this ever happened again, and unfortunately, it probably never will . . . no matter how much more practical that process sounds than Ticketmaster's Verified Fan program.

The *Speak Now* tour took the most whimsical vibes that Taylor previewed with the visuals for songs like "Love Story" and cranked them all the way up. It included the most theatrical representations of her songs, from staging a wedding for "Speak Now" to the use of real fireworks during "Dear John."

The Taylor of this era had a real affinity for Sharpies . . . for better or for worse. Not only did she use them to sign autographs, holding her pen in that weird way between her index and middle finger, but she also admitted to using them as a substitute for eyeliner (as much as it makes me cringe to even think about doing that).

How to Dress
for the
SPEAK NOW
Era

YOUR FAVORITE TAYLOR LYRIC WRITTEN DOWN YOUR ARM IN SHARPIE

GOLD ACCENTS

TULLE SKIRT

WHIMSICAL ACCESSORIES LIKE CHANDELIER EARRINGS

ANYTHING SPARKLY AND PURPLE

The best use she found for the markers, though? The song lyrics she'd write down her arm every night of the tour that gave fans a glimpse into how she was feeling—or at least what songs she'd been listening to prior to taking the stage. At the time, a fan created a now-defunct website to document all of them, Taylor-SwiftArmLyrics.com, so everyone could keep track of how the words on her arms changed from night to night.

One night in Omaha, Nebraska, the lyrics on her arm were from Alanis Morrisette's song "You Learn": "I recommend getting your heart trampled on to anyone." Months later, in Salt Lake City, Utah, they were from Jimmy Eat World's "The Middle": "Little girl, you're in the middle of the ride." Every night was different.

This might explain why Taylor has such a special knack for connecting with her fans. She's a fangirl herself, and she knows what it's like to find your own meaning and comfort in music—to hear a lyric and relate to it so deeply you'd write it on your body in permanent marker for the world to see.

The arm lyrics served as a kind of clue to what was going on in Taylor's life at the time, like one of the most visual Easter eggs she's ever shared with fans. As the *New Yorker* aptly described the genius behind her concert tradition, it showed "a keen understanding of what fuels fan obsession in the first place: a desire for intimacy between singer and listener."

Has any artist ever been able to achieve that more effectively than Taylor Swift?

Taylor had been open about how much she loved surprising fans by suddenly showing up in the back of the arena to perform during the *Fearless* tour, so she kicked that up a notch for the *Speak Now* tour. This time, there was a B stage at the back of the floor section at each venue, and Taylor would choose a different artist's song (or two) to cover, with those songs changing from night to night.

"There are a lot of moments in the show that are very spontaneous. I'm singing a different cover song every night on the B stage, just me and my guitar," she told *Billboard* in December 2011. "In those moments I can choose to play whatever the fans are wanting to hear or whatever I feel like playing that night. It's been fun to be able to vary up the show so much, especially because you'll have a lot of people who will come to more than one show, and I want them to get a different experience every time."

Even then, Taylor was thinking of her "repeat customers"—the fans who would attend as many shows on each tour as

FAN ENCOUNTER
BRIDAL SHOWER SURPRISE

Let it be known that Taylor goes out of her way for fans, especially when it comes to the ones who have been by her side since the very beginning. Though fan Gena Gabrielle has been lucky enough to meet Taylor on multiple occasions, there's one that truly sticks out.

After Gena was invited backstage at the last US stop of the *Red* tour in the fall of 2013, she had the chance to tell Taylor that she was engaged to her now-husband, Bryan. Gena says that Taylor asked her about the wedding, saying, "When is it? Remind me when it's closer."

Remembering what Taylor said, Gena decided to invite Taylor to her bridal shower the following year by sending an invitation to her management team. She never heard back, but when the day of the party arrived, she was given a big surprise when Taylor showed up, armed with gifts.

"She was on her phone a few times and said, 'I'm sorry, it's my mom. She is so excited about this. She wants updates. She was mad I was almost late. She said you can't be late to these things,'" Gena says. "One memorable moment from that day was when she was taking pictures with people and I held her phone and I changed the background to her and I. I later realized I was holding the entire *1989* album in my hands!"

This wasn't the only surprise for Gena that Taylor had up her sleeve. Just months later, Gena was invited to introduce Taylor when she was presented with the 2014 Billboard Woman of the Year award—and she was handpicked by Taylor for the task, even though Gena was told that those organizing the event were "nervous" about choosing a fan for the honor. But Taylor insisted, knowing that she would want a fan to be the one to present her with this award.

More than ten years later, Gena is still faithfully supporting Taylor. "I have met so many people through Taylor from all over the world," she says. "I love that it feels like a family."

possible. She doesn't just want to bring her tours to life in the ways she visualizes it, she also wants to create a fan-first experience every step of the way, and that never changed.

This tour was also when Taylor really began her tradition of bringing out special guests whenever she could, like Justin Bieber, Nicki Minaj, and Selena Gomez. Another unique feature of the tour was the way that Taylor mashed up her own songs with other artists' songs, like "Fearless" with Jason Mraz's "I'm Yours."

Fan behavior started changing during the *Speak Now* tour, too. Now that the backstage T-Parties where fans were chosen to meet Taylor after the show were officially A Thing, many people showed up ready to be chosen. While some people did go all out for the *Fearless* tour, efforts were amplified after they found

out there was a chance they could be plucked from the crowd to meet Taylor. A sparkly dress and cowboy boots might have been enough in the past, but now people had started showing up in full costume dressed as Christmas trees as a reference to Taylor's favorite holiday.

When my *Speak Now* shows finally came around, I took a balanced approach. On the first night in Atlanta, I did the whole glow-in-the-dark outfit, light-up-sign routine, hoping that if I was all lit up, I'd be easy to spot in the crowd. On the second night, I was more laid-back, wearing jeans and a cute top. I didn't get picked for T-Party either night, but I *did* have a lot of fun . . . and out by the tour buses, I snagged a couple of guitar picks from Taylor's dad, so I can confirm that however a Taylor Swift concert shakes out, you're going to have a good time.

THE GIRL IN THE DRESS
WROTE YOU A SONG

"Forever & Always" was Taylor's first breakup song with a very clear (and famous) muse, but it definitely wouldn't be her last, and that became evident as soon as *Speak Now* was released.

By this point, Taylor had figured out how to send fans messages through her

music to help them connect the dots and figure out which songs were about which moments and people in her personal life. The secret code found in the lyrics to "Enchanted" was "Adam," which led fans to discover it was about Adam Young, the singer from Owl City,

who apparently didn't know he was the subject of the song until the rest of the world did (but after finding out that Taylor had been "enchanted to meet [him]," he recorded his own response song, also called "Enchanted," to confess he felt the same way, though things between them never ended up going anywhere). "Back to December," meanwhile, could only be about Taylor Lautner after their relationship ran off course, again thanks to the secret code in the lyrics that spelled out "Tay."

It was also easy to deduce that "Last Kiss" was about Joe Jonas, since the secret code for that song was "forever and always," but Taylor had learned other ways to drop hints, too (and, okay, be a little petty at the same time—but that's what we love so much about her; we all feel that way sometimes!). The length of the intro of *Last Kiss* was twenty-seven seconds long, the same length of their infamous breakup phone call, in case anyone had any doubts.

When it came to "Dear John," though? The biggest clue that the song pointed to her relationship with John Mayer was in the name of the song, a play on so-called Dear John breakup letters written by unhappy wives and girlfriends to their military men. The second biggest clue was the sound of the song itself; it was like it could have been straight off one of his albums instead of one of Taylor's with the twangy guitar backing up her biting lyrics.

The relationship between fans and Taylor's ex-boyfriends has always been a very contentious one. Though there are some who fans still adore—like Harry Styles, naturally—there are some who really aren't looked upon favorably by the fandom, and that's putting it lightly. How high he ranks on the Swiftie Shit List will depend on which Swiftie you ask, but John Mayer is pretty darn close to the top.

He and Taylor starting dating sometime in 2009, after they met while recording their collaboration, "Half of My Heart." They weren't spotted together very often in public, so it's hard to pinpoint an exact timeline of their relationship (and when it ended). But in June 2010, John presented Taylor with an award at the Songwriters Hall of Fame, and by October, when *Speak Now* was released, "Dear John" made it seem like something had gone very wrong.

The age difference between John and Taylor was striking; when she sings that "nineteen's too young to be played by your dark twisted games," she struck a chord with fans who may have been in a similar situation at her age while dating someone older. At the time they were together, John Mayer was thirty-three.

WHO'S WHO IN THE TAYLOR SWIFT UNIVERSE

ANDREA AND SCOTT SWIFT

Taylor's parents, who are frequently spotted wherever Taylor is. If you go to one of her concerts, Scott will be the guy handing out the guitar picks with his daughter's face on them.

AUSTIN SWIFT

Taylor's younger brother, who also happened to dress up as Santa Claus at a Kansas City Chiefs game on Christmas Day 2023

JACK ANTONOFF

Member of the band Bleachers (some might also recognize him from the band fun.) and Taylor's close friend and collaborator. He and Taylor started working together on *1989* and they haven't stopped. Everybody, tell Jack thank you for "Getaway Car."

MARJORIE FINLAY

Taylor's maternal grandmother, who was also a singer, and the subject of the song "Marjorie"

ABIGAIL ANDERSON

Taylor's best friend since high school and the subject of the song "Fifteen"—she's the redhead who's always goofing off with Taylor in her really old vlogs!

AARON DESSNER

Best known as a member of The National, Aaron is a musician, producer, and songwriter who has collaborated with Taylor as a producer and co-writer ever since he helped her make *Folklore* and *Evermore* so magical at Long Pond Studios.

BETTY, INEZ, AND JAMES

Characters from the songs "August" and "Betty" who were named after Blake Lively and Ryan Reynolds's daughters

REBEKAH HARKNESS

The socialite who owned Taylor's home in Watch Hill, Rhode Island, before she died and the subject of "The Next Great American Dynasty"

TREE PAINE

Taylor's longtime publicist and a Lady You Do Not Want to Mess With

We don't know the particulars of their relationship, and it's hard to even guess, because they were seen together so infrequently. But from the song, we can glean—at least, from Taylor's perspective—that he took advantage of her optimism and inexperience, that her parents didn't approve of them dating, and that whatever happened to end things between them, he probably came away from it feeling like the victim.

Well, that last part we didn't learn just from the song. John Mayer didn't waste time speaking out about how he felt after *Speak Now* dropped and the world had the chance to listen to the song that everyone immediately assumed he had inspired. Two years later, in June 2012, John told *Rolling Stone* that he was "really humiliated" by the song—and keep in mind, other than using the same first name, Taylor had never (and has never) publicly confirmed that it was written about him. But clearly, John saw enough of himself in her lyrics that he confirmed it for her.

"I didn't deserve it," he said at the time. "I'm pretty good at taking accountability now, and I never did anything to deserve that. It was a really lousy thing for her to do." And then, he hit her where I can only assume he knew it would hurt the most.

"I will say as a songwriter that I think it's kind of cheap songwriting," he says. "I know she's the biggest thing in the world, and I'm not trying to sink anybody's ship, but I think it's abusing your talent to rub your hands together and go, 'Wait till he gets a load of this!' That's bullshit."

If Taylor was ever bothered by it, though, she didn't let on. In fact, her exact response when *Glamour* asked her about that article? "How presumptuous! I never disclose who my songs are about."

John might have known how to hit Taylor where it hurts, but she was just as crafty, because ignoring everything he said about the song publicly must have been a blow to his ego . . . and he wasn't quiet about it for long. The following year, he released the song "Paper Doll" that included several references that anyone who had been paying attention to Taylor would be able to pick out, calling her "twenty-two girls in one"—a reference to Taylor's song "22," which was released months earlier. Still, Taylor remained unbothered, and she stayed that way in 2016, even when John tweeted on her birthday, "Tuesday, December 13 may be the lamest day of the year, conceptually." (Author's note: John Mayer was but a whisper away from turning forty when he clicked "post" on that tweet.)

"Dear John" and John's explosive reaction to the song were plenty reason for him to end up on that Swiftie Shit List at the time, but as fans got older, and as society in general began to look at the

broadly misogynistic pop culture events of the early 2000s and 2010s with a more critical eye, they saw the relationship through a different lens. Suddenly, John wasn't just an older man who hurt our favorite singer and then acted immaturely about it for years afterward—the inherent ramifications of a thirty-three-year-old person of influence dating a nineteen-year-old were brought into sharp focus.

When *Midnights (3am Edition)* came out in 2022, Taylor was the same age that John had been when they dated. The album included the song "Would've, Could've, Should've," which seemed to be her way of looking back on what happened with the wisdom she'd gained since then. The line "I damn sure would've never danced with the devil at nineteen" really seemed to spell out who the song was aimed at, since John was the man she famously dated at nineteen.

After hearing lyrics like "give me back my girlhood / it was mine first" in "Would've, Could've, Should've," fans were gleefully looking forward to seeing John eviscerated in the vault tracks when *Speak Now (Taylor's Version)* came out in July 2023. The vitriol was so real that before playing "Dear John" as a surprise song during her Eras Tour stop in Minneapolis just a week before the album came out, Taylor asked her fans to extend their "kindness and gentleness" to the way they behave online.

"I'm thirty-three years old. I don't care about anything that happened to me when I was nineteen except the songs I wrote and the memories we made together," she said, adding, "I'm not putting this album out so you can go on the internet and defend me against someone you think I wrote a song about fourteen million years ago."

Of course, online hate is never okay, no matter what may or may not have happened between Taylor and an ex-boyfriend more than a decade ago. But it says a lot about Taylor that she can inspire her fans to hold a grudge against someone for that many years. And that when she asks them to stop holding that grudge, they listen. Mostly.

RED

THE "ALL TOO WELL" ERA

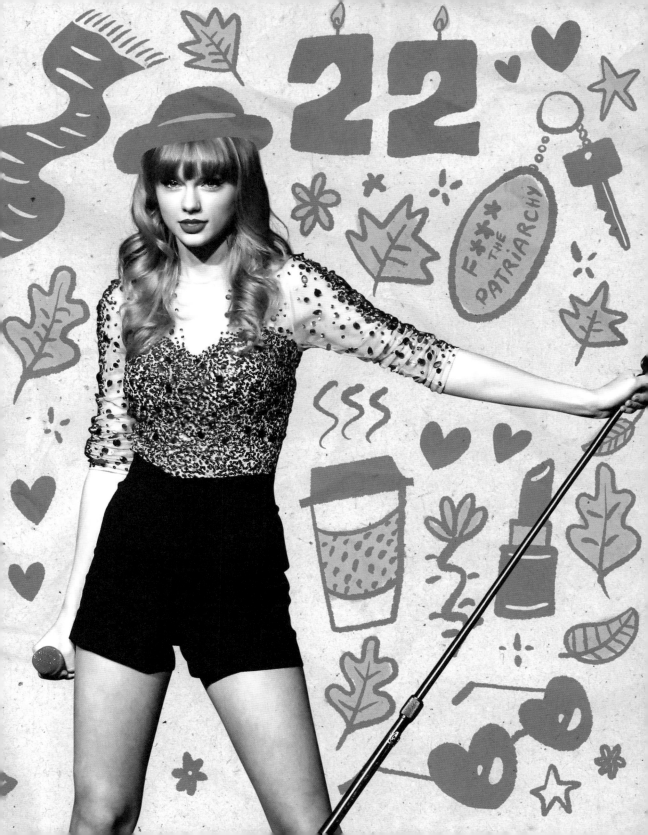

In the song "22," Taylor describes your early twenties as being "happy, free, confused, and lonely in the best way," and that's exactly where I was at when *Red*— my favorite of her albums—dropped in 2012. I was living in New York City, interning at *Seventeen*, and everything was going according to plan . . . but somehow I felt like a total mess at the same time. The morning of the album's release, my long-distance boyfriend, Blake (who would eventually become my husband), said goodbye to me as he flew back home to Georgia, and I cried on the subway for the first time that day. A few hours later, I'd be standing in front of the Times Square Walgreens, posing for a selfie with Taylor. The life of a Swiftie.

LOVING HIM WAS RED

The Swiftie community referred to Taylor's album cycles as eras long before Taylor ever did, and *Red* was the first album that existed inside its own bubble with a clear delineation between the music that came before and after—not just in sound, but in aesthetics, too.

While Taylor's debut album, *Fearless*, and *Speak Now* were all unique albums with a sound that was gradually drifting away from what we think of as country music, they gave off similar vibes: fairy-tale love, bright colors, whimsy, sparkles, dresses. Taylor's style and hair were the same through each of those eras, too, down to her trademark curls. But as the *Speak Now* album cycle wrapped up, Taylor was changing. She was now solidly in her twenties, and her next album would reflect maturity.

There are a few different markers of a Taylor Swift era, other than a new album, of course. Her hair changes. Her style, down to the clothes she wears, changes. Her social media aesthetic changes. And even though this wasn't clear until years down the line, each era is assigned a color. One branding expert, Rebecca Horan, calls Taylor's method "authenticity plus strategy." "As she evolves through her eras, each change feeds a leaning or longing that her fans aren't yet even aware of. It's almost as if she has a 'preview' window into the zeitgeist. She knows what's going to be resonant before the rest of us are there," Horan says. "Her era evolutions are a genuine reflection of where she is and what she's going through in life—carefully worded, positioned, and styled in the way that her

audience is going to most deeply connect with."

This kind of brilliant reinvention also means that every album she releases is new and fresh. Her existing fans don't get bored. People who had never listened to Taylor before see something they like that wasn't there before and get pulled in. It works every time, and the first time this formula really became clear and distinct enough to notice was *Red*.

At first, Taylor's new hairstyle ushered in the biggest *Red*-era change. We said goodbye to the curls and hello to straight hair and bangs cut across her forehead that she, more or less, has decided to stick with ever since. She'd always been a fan of red lipstick, but she cranked it up a notch during this time. Taylor's wardrobe suddenly had all the vintage vibes, and she traded in her cowboy boots for oxford shoes as she adopted the modernized twee style that was so popular in 2012. Some people have called it her "grandma" era, but they must have forgotten just how massive the TV show *New Girl* was back then. Taylor's style was essentially whatever was in Zooey Deschanel's character's closet but with her own twist. It totally worked for Taylor (especially while she was hanging out with the Kennedys— more on that soon).

Like when she announced *Speak Now*, Taylor decided to live stream the *Red* album announcement, too, but this time, she did something new, inviting a small group of fans to be there with her. She also spilled all the beans right away: the album name, cover, *and* the premiere of the first single. She even answered questions about the album, from fans both there in person and those live chatting with her on Google+, a now-defunct social media platform. Again, let's pause to remember a time when Taylor Swift had not yet morphed into some kind of wildly talented woodland creature who required us to answer her riddles three before she would give us even a hint about what her next album would be.

Above all else, red being the color assigned to this era was the defining characteristic, because to Taylor, it was so much more than a color; it was a full-blown concept.

In the prologue to her album, Taylor called the most intense relationships of her life "red relationships," or "the ones that went from zero to a hundred miles per hour and then hit a wall and exploded. And it was awful. And ridiculous. And desperate. And thrilling. And when the dust settled, it was something I'd never take back." And just like the word *fearless*, the word *red* and what it

How to Dress
for the
RED
Era

- HEART-SHAPED SUNGLASSES
- HIGH-WAISTED SHORTS
- RED SCARF
- BLACK-AND-WHITE-STRIPED SHIRT
- "NOT A LOT GOING ON AT THE MOMENT" T-SHIRT

TOP 5 TRACK FIVES

It doesn't matter what Taylor Swift is singing about—she knows how to write a song about anything (and a killer bridge). But where she really shines are those songs in which she's actively trying to rip our hearts out, and we will find most of those songs in the fifth spot on her album track listing. At this point, we don't even need to hear her next album to predict that track five is absolutely going to make us cry.

This isn't something that Taylor did consciously at first, as she told fans who tuned in to one of her Instagram live streams during the release of *Lover*. "I didn't realize I was doing this, but as I was making albums, I guess I was just kind of putting a very vulnerable, personal, honest, emotional song as track five," she explained. "So because you noticed this, I kind of started to put the songs that were really honest, emotional, vulnerable, and personal as track five."

Track fives don't just make us cry, though; they also happen to be some of Taylor's most lyrically impressive songs. It's incredibly hard to choose the *best* track five, but these are the five that have truly become fan favorites.

"ALL TOO WELL"

Of course, the ten-minute version is about four and a half minutes more heartbreaking than the original, snack-size version on *Red*, but between the actual lyrics, the story behind the song, and the years of lore between Taylor and the fans that has been built up around it, this is the track five to end all other track fives.

MOST DEVASTATING LYRICS: "So you call me up again just to break me like a promise / So casually cruel in the name of being honest"

"TOLERATE IT"

This song from *Evermore* is basically one long gut punch that somehow became even sadder after seeing Taylor perform it live on the Eras Tour. What's sadder than feeling invisible in a relationship?

MOST DEVASTATING LYRICS: "You assume I'm fine, but what would you do if I / Break free and leave us in ruins / Take this dagger in me and remove it / Gain the weight of you, then lose it / Believe me, I could do it"

"DEAR JOHN"

It's hard to believe that this song is from *Speak Now*, because the Taylor who wrote this truly was wise beyond her years, looking back at a relationship where she was taken advantage of by an older man.

MOST DEVASTATING LYRICS: "Don't you think nineteen's too young / To be played by your dark twisted games when I loved you so?"

"MY TEARS RICOCHET"

What's this? Oh, just a song Taylor wrote for *Folklore* about the heartbreak of being betrayed by the people who sold her masters out from under her. The loss of her back catalog had to be much more painful than the loss of any relationship could ever be.

MOST DEVASTATING LYRICS: "I didn't have it in myself to go with grace / 'Cause when I'd fight, you used to tell me I was brave"

"YOU'RE ON YOUR OWN, KID"

Unlike the others on this list, this *Midnights* song isn't necessarily sad, but it does pack a major emotional punch. Taylor looking back at everything she's been through to get to where she is now is enough to get the tears flowing.

MOST DEVASTATING LYRICS: "I hosted parties and starved my body / like I'd be saved by a perfect kiss"

could mean had been forever changed for those devoted to her music.

While some might call *Red* one of her least-cohesive records—and also her final "country" album—that also makes it arguably the most interesting. "I Knew You Were Trouble" sounds nothing like "All Too Well," which sounds nothing like "We Are Never Ever Getting Back Together" which sounds nothing like "Everything Has Changed," but these songs all connect in the way that they represent Taylor's idea of red relationships. The track list might be a little messy, but so is love, so in the end, didn't she achieve her goal?

SO CASUALLY CRUEL IN THE NAME OF BEING HONEST

It was during the *Red* era that Taylor made headlines for dating Conor Kennedy, Robert F. Kennedy Jr.'s son. From the outside, it seemed that she was falling hard and fast; her song "Starlight" was inspired by the love story between his grandparents, Ethel and Robert F. Kennedy, after all, so things between them seemed to be getting very serious, very quickly.

Then there was Harry Styles, of whom you might have heard. He and Taylor were together when *Red* was released, back when he was still a part of One Direction. The story of their relationship—and how it went wrong—would eventually be told on *1989*.

But even though Taylor's relationship with Jake Gyllenhaal had already been over for a while by the time *Red* came out, he is the one who is intrinsically linked to it, since many of the songs on the track list are rumored to be inspired by him.

Out of all of the songs on *Red*, the one that is still talked about the most is, unquestionably, "All Too Well." Though Taylor has since admitted she didn't expect it to get the response that it did, it would have been hard for fans to avoid taking this song very, very personally. With some of the most raw, heartbreaking lyrics that she's ever written, it's easy to see why "All Too Well" became the blueprint for all track five songs to come—the spot on each album where Taylor (consciously or not at first), puts the saddest song of the era. It was this song that fans couldn't stop talking about, and it was the one that Taylor chose to perform at the Grammy Awards in 2014, even though it had never been

a single. It took on a life of its own and, even now, is still considered by many to be one of the best songs she's ever written and recorded.

Before the album was released, in an interview with *USA Today*, Taylor hinted that this song was about to destroy us all. Days before *Red*'s release, she said she'd written "All Too Well" with songwriter Liz Rose after six months of not being able to write anything. "There's a kind of bad that gets so overpowering you can't even write about it. When you feel pain that is so far past dysfunctional, that leaves you with so many emotions that you can't filter them down to simple emotions to write about, that's when you know you really need to get out," she said.

By the time the album was out, it was clear that Taylor hadn't been exaggerating. But who was it about? The secret code hiding in the liner notes, "maple latte," only pointed to one person. In November 2010, *People* reported that Taylor and Jake had stopped into a coffee shop called Gorilla Coffee in Park Slope, a neighborhood in Brooklyn, where a witness at the store said they'd ordered specialty maple lattes. They'd been photographed by paparazzi the same day, holding cups from Gorilla Coffee.

According to Taylor, Jake had *really* done a number on her . . . and according to her, we hadn't even heard the half of it. During an appearance on *Good Morning America* during the *Red* release week, Taylor mentioned that the original version of "All Too Well" had been the hardest for her to write, partly because there was so much she wanted to include in the song. "It started out being probably, like, a ten-minute song, which you can't put on an album, and I had to filter it down to a story that could work in the form of a song," she said.

In true Swiftie fashion, we took that statement and *ran* with it. Taylor probably had no idea that this would be the start of a massive piece of fandom lore, but it truly took on a life of its own. Fake lyrics for the ten-minute version of "All Too Well" would float around online every so often. There were at least a dozen convoluted, behind-the-scenes stories about the writing session between Taylor and Liz Rose from "sources" as wide-ranging as a concert crew member to Mama Swift herself.

While on *Rolling Stone*'s "500 Greatest Albums" podcast in 2020, eight years after "All Too Well" had first been released into the world, Taylor shared even more about the mythical ten-minute version of the song. "It was that song but probably had seven extra verses. I included the f-word, and I remember my sound guy was like, 'I burned a CD of that thing you were doing in case you

want it,'" she said. "I ended up taking it home and listening to it and I was like, 'I actually really like this, but it's ten minutes long."

It's a good thing she kept that version of the song, because it would come in handy years later, when she was re-recording her albums and decided it was finally time to give fans what they'd been waiting for on *Red (Taylor's Version)* when it was released in 2021.

Astonishingly, "All Too Well" became even more heartbreaking in its longer form. The new lyrics were even more biting and painful, and so was the short film that Taylor released alongside it. In the film, the narrator of the song is a grown-up author who had written a book about the toxic relationship she had with a much older man when she was younger and trying desperately to fit in with him and his friends.

As deeply sad as the song and the true story behind it were, "All Too Well" ended up as more of an anthem that represented Taylor's relationship with her fans. Its new iteration was born from our fandom and the way we made it our own. By including it in the rerecording

of *Red*, Taylor demonstrated that she listens to her fans.

In an interview released by Republic Records in 2021, Taylor said that because of that connection, the story behind the song was now "so sacred." "I knew that when we put out the album, it wouldn't be a single, it wouldn't be a video—but I knew it was my favorite one," she said. "And what was so crazy is that when it went out into the world, the fans just among themselves decided it was their favorite, too. They just sort of . . . claimed it as the most important song from *Red*." She added, "For me, this song has turned into a story of what the fans did, really."

While hearing more of what went wrong between Jake and Taylor *did* spring a new round of online hate flying his way, to his credit, he was a good sport about it all. "It has nothing to do with me. It's about her relationship with her fans. It is her expression. Artists tap into personal experiences for inspiration, and I don't begrudge anyone that," he said in a 2022 interview with *Esquire*.

Maybe he and John Mayer should have a chat?

FAN ENCOUNTER
CLUB RED

When a fan named Dina went to the *Red* tour in Tacoma, Washington, on August 31, 2012, she thought that her amazing B-stage seats would be the closest she'd get to Taylor that night after being a fan since the first time she heard "Tim McGraw" in 2007. But as it turned out, she was wrong.

She and her friends grabbed Mama Swift's attention with their glittery, light-up signs that spelled out "TAY" with a heart, and when Dina tried to give her the letter she'd hoped to pass on to Taylor, Andrea did her one better. "She looked back at the letter I gave her, still in her hands, and said, 'Did you want to give this to Taylor yourself?' There were no amount of T-Party videos, Taylor meet and greet stories, or personal daydreams that could have fully prepared me for this moment!" Dina says.

When it was finally Dina's turn to meet Taylor at Club Red, she was greeted with a hug. "I gave her the card I made and she opened it up right there. It had pictures of my friends and [me] at previous shows. 'Thank you so much for coming to so many shows,' she said while holding my hands tightly," Dina continues. "I also gifted her a cat necklace and showed her that I had the matching one. 'Yay, now we can be twins!' she said.

"Meeting Taylor was something I dreamed about for so long and it finally happened and exceeded any expectation I ever had," says Dina. "She was so sweet and attentive and took her time with every fan. You would never know she was a massive pop star, but instead made everyone feel like an old friend. In that moment I knew I picked the best role model to look up to when I was twelve years old."

THE *RED* TOUR

The *Red* tour was a bit shorter than her previous two world tours, with eighty-six shows across North America, Europe, Asia, and Oceania, but she made it count. Since Taylor was still considered a country artist at this point, pulling in more than $150 million in revenue made this the highest-grossing country tour in history at the time—and in the years since then, it's still hung in there near the top of the list.

Some of Taylor's traditions from the *Fearless* and *Speak Now* tours continued when she took *Red* on the road, including performing surprise songs every night. This time around, she picked from her own discography.

During an interview with *Rolling Stone*, she explained why the surprise elements of her concerts were so important to her—because of us, duh. "Variety in entertainment can be so inspiring, and that's why I like to create different worlds with each song. It's why I like surprising the crowd with special guest performances they didn't expect," she said. "The fans have made my world a magical place to live in, and I guess this tour is me trying to do the same for them."

She also managed to bring out unexpected celebrity guests during the tour, too. Carly Simon joined her onstage in Foxborough to perform "You're So Vain," and Jennifer Lopez surprised fans onstage in Los Angeles to sing "Jenny from the Block," among more than a dozen other performers. The *Red* tour is where so many fans were introduced to Ed Sheeran, who had formed a close friendship with Taylor after recording "Everything Has Changed" together for the album and joined as her opening act.

There was also a new version of the T-Party to think about for those who still had dreams of being plucked from the crowd to meet Taylor. This time, it was called Club Red, though it was earned in the same way—by dancing and singing your heart out during the show, and, more importantly, finding a way to make yourself stand out in the crowd, either by the way you dressed, the sign you brought, or both. Knowing this, many fans really took their competitive streaks up a notch. Looking out into the crowd during the show on any given date during the tour meant seeing a lot of different signs that lit up or glowed in some way, especially in the nosebleed seats toward the top of the stadium.

The *Red* tour was one of the most fun to experience as a fan, too. Once again, I tried (and failed) to be selected for Club Red during the final night of the

US leg of the tour in Nashville, and even though it didn't end up happening, I had a blast singing and dancing with one of my best friends. And while walking to my seat, I ran into Mama Swift. Despite the hundreds of thousands (if not millions) of fans whose paths she's crossed over the years, she somehow knew that she'd met me before. Immediately, she reached out to give me a hug, asked me how I've been, told me it was good to see me again. Before we parted ways, she said, "See you soon!" It's not just Taylor who has a way of making everyone she interacts with feel like they're a close friend, even if they barely know her—she learned that from somewhere, and from my experience, it must have been passed down from her mom.

As this era came to a close, one more important thing happened during the *Red* tour that signaled that the next era was already on its way: Taylor chopped off her hair backstage, turning her signature long blond locks into her *1989*-era bob while her friends, bandmates, dancers, and even her mom looked on. When the tour stopped in London, one of the last few dates in 2014, Taylor posted a photo of herself posing with Ellie Goulding and showing off the shortest haircut her fans had ever seen from her.

An even bigger change was coming in just a few months, and Taylor was about to shift into a level of superstardom she'd never reached before . . . for better or for worse.

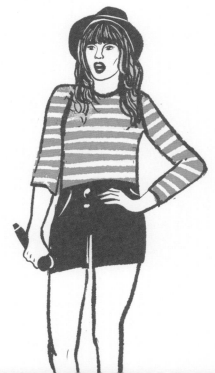

HAIRSTYLES
THROUGH THE ERAS

DEBUT

FEARLESS

SPEAK NOW

RED

1989

FOLKLORE

EVERMORE

LOVER

MIDNIGHTS

REPUTATION

THE
TORTURED
POETS
DEPARTMENT

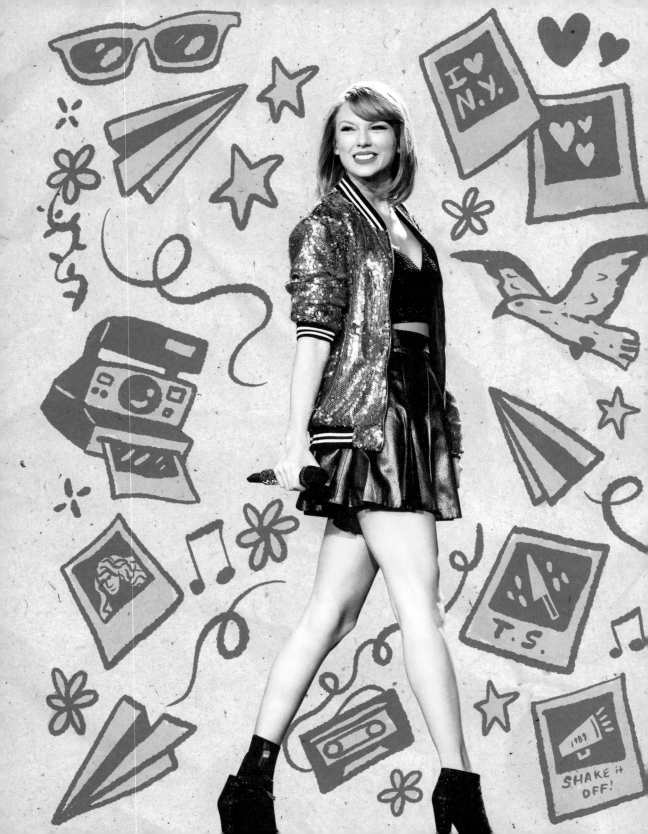

1989

THE
POLAROID
ERA

The *1989* era began just as I felt like my real life was beginning. I had moved back to the Atlanta suburbs and into an apartment with Blake, we had adopted a cat, I'd started my career as a full-time freelance writer, and I was officially a Real Adult—right around the time that Taylor was becoming a Real Pop Singer. Unfortunately, "Bad Blood" was a little too relatable during this time, but even when I realized that some of my best friends simply weren't there for me anymore, Taylor and her music always had been.

SHE LOST HIM,
BUT SHE FOUND HERSELF

If we were talking about almost any other artist, this would be the most exciting part of Taylor's story—the part where she lays her claim to fame and grabs her highest level of success. This was *almost* the peak of her career (and I wouldn't be surprised if she thought it was, too). But this is Taylor we're talking about, and instead, *1989* simply turned into the era that would be the divider between what her career had been and what it would become.

After all, this is also when she started working with Jack Antonoff, the producer behind so many of Taylor's biggest hits since then—and the man who is never too shy to dunk on Kanye West on social media. Without him, we wouldn't have "Getaway Car" *or* the behind-the-scenes footage of the making of "Getaway Car."

Two big transitions happened for Taylor during this time: She officially crossed over into the pop genre, and she moved to New York City. And much like many girls from far-reaching corners of the US who move to New York City in their early twenties (myself included), she never stopped talking about it. "I dreamt about moving to New York. I obsessed about moving to New York and then I did it," Taylor said on *Good Morning America* the week before *1989* dropped in October 2014. "The inspiration that I found in that city is kind of hard to describe and hard to compare to any other force of inspiration I've ever experienced in my life. I approached moving there with such wide-eyed optimism and sort of saw it as a place of endless potential and possibilities."

New York would turn out to be the setting of so many of Taylor's songs, on *1989* and beyond, but during this era, she really was all over the place: New York City, the Holiday House in Watch Hill, Rhode Island (more on that later), Los Angeles, and back to Nashville. Looking back, it makes sense that Taylor would disappear for a year after this era came to an end—did she ever take a day off?

> "This is not about me. Thankfully, I am on my fifth album and can support myself, my band, crew, and entire management team by playing live shows. This is about the new artist or band that has just released their first single and will not be paid for its success. This is about the young songwriter who just got his or her first cut and thought that the royalties from that would get them out of debt. This is about the producer who works tirelessly to innovate and create, just like the innovators and creators at Apple are pioneering in their field . . . but will not get paid for a quarter of a year's worth of plays on his or her songs."

While *1989* definitely made an indelible mark all on its own, it's not the only way Taylor changed the music industry during this time. This is also when she used her power and influence to fight streaming services head-on, starting with Spotify. In November 2014, Taylor pulled her entire catalog from the service, explaining her decision in an interview with Yahoo. "Music is changing so quickly, and the landscape of the music industry itself is changing so quickly, that everything new, like Spotify, all feels to me a bit like a grand experiment," she said. "And I'm not willing to contribute my life's work to an experiment that I don't feel fairly compensates the writers, producers, artists, and creators of this music. And I just don't agree with perpetuating the perception that music has no value and should be free."

Eventually, Taylor came for Apple Music, right around the time it launched. In June 2015, Taylor pointed out in a post on Tumblr that the service was offering free three-month trials to potential subscribers, and during that time, artists would not be paid for their

How to Dress
for the
1989
Era

~~~~~~~~

**BLUE-AND-YELLOW CHEERLEADING UNIFORM**

**A SEQUIN BOMBER JACKET**

**A CROP TOP WITH A SKIRT**

**YELLOW "NO ITS BECKY" T-SHIRT**

**A SPARKLY TWO-PIECE SKIRT-AND-TOP SET**

streams—something she called "shocking." She wrote:

"This is not about me. Thankfully, I am on my fifth album and can support myself, my band, crew, and entire management team by playing live shows. This is about the new artist or band that has just released their first single and will not be paid for its success. This is about the young songwriter who just got his or her first cut and thought that the royalties from that would get them out of debt. This is about the producer who works tirelessly to innovate and create, just like the innovators and creators at Apple are pioneering in their field . . . but will not get paid for a quarter of a year's worth of plays on his or her songs."

This was Taylor's way of fighting for the little guy, and at this point in her career, she was big enough that it actually worked. The very next day, Apple responded, announcing that they would be paying artists during these three-month trial periods. "When I woke up this morning and saw what Taylor had written, it really solidified that we needed a change. And so that's why we [decided] we will now pay artists during the trial period," Apple's senior vice president of services, Eddy Cue, told *Billboard*. "I let her know that we heard her concerns and are making the changes. We have a long relationship with Taylor so I wanted her to hear directly from us."

Taylor would go on to form a partnership with Apple Music, releasing the *1989* world tour documentary on the streaming service (and giving us that epic commercial where she's running on a treadmill while listening to "Jumpman" by Drake and Future). Meanwhile, it wasn't until June 2017 that she decided to make her entire back catalog available on Spotify (and all streaming services) again, making her music accessible to more fans than ever.

This was definitely a good thing, because it seemed like fans and critics alike were analyzing *1989* as well, trying to find clues about Taylor's personal life—particularly when it came to her relationship with Harry Styles. Though they'd been spotted out and about a few times, especially when they were both in New York, there were still so many blanks that hadn't been filled out.

*1989* helped with that a little. The song "Style" was the most blatant, given the title (and the fact that One Direction's song "Perfect," which was released the following year, seemed to be Harry's response). In an interview with *Rolling Stone*, Taylor said that "Out of the Woods" was about a snowmobile accident that had happened while an ex was driving. Thanks to fans' detective work,

we deduced that it was Harry at the scene of the crime when he showed up with a bandaged chin after he and Taylor were seen vacationing at a ski resort together in December 2012, though neither of them have ever confirmed that part.

> "We begin our story in New York. There once was a girl known by everyone and no one. Her heart belonged to someone who couldn't stay. They loved each other recklessly. They paid the price. She danced to forget him. He drove past her street each night. She made friends and enemies. He only saw her in his dreams. Then one day he came back. Timing is a funny thing. And everyone was watching. She lost him, but she found herself, and somehow that was everything."

And then, as usual, there were the secret codes in her liner notes. Usually, each song had an individual message, but this time Taylor appeared to be sharing the story of her relationship with Harry, starting with "Welcome to New York" and ending with "Clean":

"We begin our story in New York. There once was a girl known by everyone and no one. Her heart belonged to someone who couldn't stay. They loved each other recklessly. They paid the price. She danced to forget him. He drove past her street each night. She made friends and enemies. He only saw her in his dreams. Then one day he came back. Timing is a funny thing. And everyone was watching. She lost him, but she found herself, and somehow that was everything."

Unfortunately for those of us who wish it had turned out differently, Haylor is in the past. But that doesn't mean I didn't squeal when I saw the two of them catching up at the Grammys in 2023 between commercial breaks—or when I noticed that Taylor was the first one on her feet to start the standing ovation when Harry won Album of the Year for *Harry's House*.

# FAN ENCOUNTER

## THE *1989* RELEASE PARTY

After seeing Taylor perform at the *Red* tour, Emily Bowen decided to turn her Tumblr into a Taylor Swift fan blog, and this ended up leading to some seriously amazing things. Not only did she make some new friends, but she also caught Taylor's eye—Taylor even followed her back! Right before *1989* was released, Emily got the coveted DM from Taylor Nation, and soon enough, they were asking her if she could make it to New York in just one week. Emily lived in Oklahoma, but she said yes and made it happen.

Taylor performed for the crowd, and soon it was Emily's turn to talk to her. Emily says:

"We talked about so many things, random stuff, but then I opened the conversation up about music and songwriting. I asked her what she does when she's in a creative slump. And she told me about her songwriting process on a deeper level than I feel like I've heard her discuss in interviews. She explained some different ways to tune your guitar, some creative writing processes she uses to help her, and talked about things outside of songwriting that help her get her creative juices flowing. She even discussed some of her struggles and it felt like two friends having a late-night heart-to-heart. It was such a natural and easy conversation."

But Taylor and Emily's connection didn't end when their first meeting did.

"After that day, Taylor continued to like my posts and keep up with me on social media. Right after the album release party, I found out my father was diagnosed with stage 4 cancer and unfortunately passed away only ten weeks after that. It was by far the hardest thing I've ever had to go through. And yet, the next day, Taylor reached out to me, offering her condolences and kind words," Emily says. "I am proud to be her fan and still admire the humble and sincere person she is. Beyond her incredible talent and who she is as a performer, I admire her character and her heart. She is a true legend."

# #TAYLURKING

The *1989* era was the most famous Taylor had ever been (according to the haters, she was too famous already), but despite how high her star had risen, this was also her most accessible era when it came to her relationship with her fans. She might have just successfully launched her first true pop album to great success, eventually winning her Album of the Year at the Grammys for the second time, but she made sure she was reachable to her fans in every way possible.

This era might have been when Taylor was the most active on social media, especially on Instagram. Not only was she commenting on fans' posts and popping in when a Swiftie would go live, but she was also sharing so much of herself at the same time—photos with her friends, photos with then-boyfriend Calvin Harris, that picture of the one-year-anniversary cake she baked for them that was definitely not her best work (sorry, Taylor). It's almost hard to believe what a personal peek she once gave fans into every facet of her life, thanks to social media. Now she's very much all business online, but back then, that wasn't enough—she even joined another site to stay connected to her fans.

Early in the era, Taylor jumped headfirst into the world of Tumblr. She made her first post on September 13, 2014,

announcing, "I'm locking myself in my room and not leaving until I figure out how to use my Tumblr. Well, I might leave for a second to get a snack or something but that is IT. I am focused."

She might have been new to the platform, but she caught on quickly, and it became clear right away that she was going to use the site as a way to interact on a more personal level with her fans. It's almost like she was joining the fandom herself—she participated in the inside jokes and seemed to have no problem making fun of herself, mocking her own former fashion choices. She followed many of her fans back, complimented the photos they'd share of themselves, and even answered their questions. This is also where she shared the now-famous recipe for her chai sugar cookies, and where would we be without that?

Taylor took this opportunity to reach out to fans, offering advice and wisdom like the big sister who everyone needed when a Swiftie would talk about going through a breakup or struggling to fit in at school. In response to one fan dealing with heartbreak, she wrote, "I'm devastated to hear you're feeling this way, and I wish I could make it go away. You're so wonderful and I wish you knew that. You're loved, even when you feel alone.

Hang on. It gets easier, and then it gets okay, and then it feels like freedom."

Being able to interact with fans on this level meant that it was even easier for her to do something she'd never done before: Secret Sessions. This was the first era that Taylor would invite handpicked fans to her home to listen to her album before it dropped, and the part of the fan base who hadn't been invited had *no* clue it was happening until it was already over. Of course, that might have been at least partially because everyone who was invited signed NDAs, but it's also because of the level of fan loyalty that Taylor commands. Her fans follow her wishes genuinely because it's what she asked them to do.

Allowing fans into their home isn't something that most celebrities ever do, but for Taylor and the relationship she has cultivated with *her* fans, it seemed totally natural. Of course, there were a few hiccups here and there, like when someone told her there was no soap in the bathroom, and she discovered that fans were taking the soap as a souvenir from their visit.

"So then I just put all these little soaps in the bathroom, so that if they wanted to take them they could," Taylor explained during an appearance on the UK's *Chatty Man* in 2014. "If you want to take the soaps, then I will make it readily

available for you to steal them. At least no one's going to go without soap now; I don't want to come off as unclean."

If this happened to anyone else, they probably wouldn't be as forgiving—let alone supplying more of the item that the thieves were making off with. But this is just another example of how much Taylor thinks about and cares for her fans. Even if it's just a bar of soap, the gesture is about so much more than that.

If all of that wasn't enough, this was also the era of Swiftmas in December 2014. As Taylor herself described it: "Shortly after the massively successful release of *1989*, fans on social media began to experience another phenomenon. After something that became known as #Taylurking, whereupon every detail of a fan's likes, job, whereabouts was studied intently . . . a single Santa emoji would appear on their socials. From one Taylor Swift . . . These are their stories."

Taylor stole the #Taylurking terminology from fans, who used it to talk about when Taylor was online on Tumblr, actively liking and reblogging posts. And as it turns out, the word would be something she took very seriously.

In a YouTube vlog, she documented the process of going shopping for presents specifically for fans she'd noticed on social media. She wrapped each gift herself, including personalized gift tags

and letters to all her recipients, and even showed herself wrapping everything in bubble wrap and packing it up before they made their way to the lucky fans she had chosen to surprise.

Make no mistake—these were not identical boxes of Taylor Swift merch that anyone could buy online. These were actual presents that Taylor personally chose for each fan, after getting to know them and their likes and dislikes on social media. She explained why she'd chosen each gift in handwritten messages on the tags, but in the case of one fan, Steph, she went further and showed up to her house in Connecticut to deliver presents to her and her son in person.

With how much our favorite celebrities share online, whether it's through their TikTok videos or their Instagram Stories or even just in interviews, it's easy to feel like we know them, with some even feeling as if they are our best friends. That is how parasocial relationships are born. But Taylor specifically chose to take such a personal role in her fans' lives—and at a time when she didn't need the positive press, since at this point, she was pretty widely beloved, even if it wouldn't last forever.

Christmas gifts, words of advice, sharing in our jokes: These are all just part of what has made Swifties so loyal to Taylor.

# I WOULD VERY MUCH LIKE TO BE EXCLUDED FROM THIS NARRATIVE

When it came to Taylor's personal life, it seemed like the *1989* era was a major high. In early 2015, she started dating Calvin Harris, and suddenly she was always surrounded by a group of best friends that was referred to by the media as her squad.

While Taylor's longtime BFFs, Abigail Anderson and Selena Gomez, had always been in the picture, at this point she was welcoming a lot of new celebrity friends into the fold. One of the closest

friendships she developed during this time was with model Karlie Kloss, who would later disappear from Taylor's life without much of a trace. Others who were frequently seen with Taylor during this time included Hailee Steinfeld, Lena Dunham, Kendall Jenner, Zendaya, Lorde, Martha Hunt, Cara Delevingne, Gigi Hadid, and Lily Aldridge.

Many of these pals were included in her music video for "Bad Blood," which ultimately ended up being a cameo-

packed music video filled with Taylor's most famous friends. After there had been so much discourse about Taylor's romantic life, now she seemed more focused on her female friendships than anything else—but she couldn't escape criticism about that, either. Later, Taylor reflected on that criticism in a personal essay entitled "30 Things I Learned Before Turning 30" that she wrote for *Elle*. "Even as an adult, I still have recurring flashbacks of sitting at lunch tables alone or hiding in a bathroom stall, or trying to make a new friend and being laughed at," she wrote. "In my twenties I found myself surrounded by girls who wanted to be my friend. So I shouted it from the rooftops, posted pictures, and celebrated my newfound acceptance into a sisterhood, without realizing that other people might still feel the way I did when I felt so alone," she continued. "It's important to address our long-standing issues before we turn into the living embodiment of them."

With all the criticism she was receiving about her squad (and so many other choices she was making at the time), Taylor was still thinking of her young fans and how her behavior might be making them feel. They say hindsight is 20/20, though, and in the middle of the chaos that was the *1989* era, she didn't have this kind of perspective just yet.

Things started to go downhill for Taylor and her personal brand in 2016—and in a big way. The backlash against the formation of her "squad" was louder than ever, with many accusing her of showing off these friendships as a publicity stunt and of peddling a white-washed, capitalist version of feminism to her fans.

In one story published in *The Ringer* in July 2016 titled "When Did You First Realize Taylor Swift Was Lying to You?" writers took turns sharing the moments they felt that they had discovered Taylor's image had been manufactured (in their opinion), going all the way back to *Speak Now*. It seemed like everyone was in the middle of playing that game, just waiting to catch Taylor in the "gotcha" moment they were all so convinced was coming. This seemed like an extreme response to who Taylor had shown herself to be so far—a pretty genuine person. It's also not the kind of response that people and the media have toward most other celebrities, either.

Unfortunately, when a powerful woman is at the top of her game, there are twice as many people waiting to witness her downfall as there are cheering her on, and in Taylor's case, this effect was magnified. Taylor Swift is, believe it or not, a mere mortal, and with such a long and widely observed career, there are always going to be valid criticisms of

# SURPRISE GUESTS OF THE 1989 TOUR

When it came to surprising fans with celebrity guests on the *1989* tour, Taylor did not hold back. Here are some of the biggest stars who appeared onstage with her:

| | |
|---|---|
| SERENA WILLIAMS | JUSTIN TIMBERLAKE |
| . . . . . . . . . | . . . . . . . . . |
| THE WEEKND | STEVEN TYLER |
| . . . . . . . . . | . . . . . . . . . |
| MARISKA HARGITAY | MICK JAGGER |
| . . . . . . . . . | . . . . . . . . . |
| THE US WOMEN'S NATIONAL SOCCER TEAM | IDINA MENZEL |
| . . . . . . . . . | . . . . . . . . . |
| JULIA ROBERTS | SELENA GOMEZ |
| . . . . . . . . . | . . . . . . . . . |
| MARY J. BLIGE | HEIDI KLUM |
| . . . . . . . . . | . . . . . . . . . |
| KOBE BRYANT | GIGI HADID |
| . . . . . . . . . | . . . . . . . . . |
| LISA KUDROW | KELSEA BALLERINI |
| . . . . . . . . . | . . . . . . . . . |
| AVRIL LAVIGNE | |
| . . . . . . . . . | |

her and her work, but at this point, those valid criticisms were all being buried by people who wanted to make sure to get their shot in.

It was around this time that her relationship with Calvin Harris (real name: Adam Wiles) came to an end, too, and explosively so. At the beginning of their split, it seemed like these two were going to keep it amicable; after the news broke, Calvin tweeted, "The only truth here is that a relationship came to an end & what remains is a huge amount of love and respect"—a message that Taylor retweeted herself. But things quickly spiraled out of control. Just a few weeks later, Taylor took her relationship with Tom Hiddleston public (a relationship that came totally out of left field for those of us simply watching this all play out from home while also coming up with the nickname Hiddleswift in record time), and that seemed to trigger Calvin to share his *real* thoughts about Taylor in a series of tweets that he later deleted.

While engaging with his ex-girlfriend's fans who questioned his behavior, he wrote, "She controlled the media and this situation. I had no idea what was going on. So that kind of makes it a lot worse from my perspective."

The breakup led to the revelation that Taylor had actually written Calvin's hit song "This Is What You Came For" under the pseudonym Nils Sjoberg, after a source claiming to be connected to Taylor dropped the intel to *TMZ*, which her rep, Tree Paine, would later confirm. This prompted a new round of tweets from her ex that he would *also* delete later, including one that said, "I figure if you're happy in your new relationship you should focus on that instead of trying to tear your ex bf down for something to do."

For those of us who frequently end up getting caught up in arguments with total strangers on the internet in Taylor's defense (guilty) this was just a warm-up of what was to come. That ill-fated call with Kanye West hit the internet just a few weeks later. Yeah, this was a busy summer in the Taylorverse.

Earlier in 2016, Kanye's song "Famous" was released. The rap where Kanye name-dropped Taylor—you know, with the lyrics that she did not approve of—wasn't just wildly offensive, but it was also fundamentally untrue. He did not, in any way, shape, or form, make that bitch famous; that bitch had been so famous before he interrupted her on that VMAs stage that she was only a few months away from winning her first Album of the Year Grammy when it happened. (Wait, should I send him a copy of this book?)

The situation became even more horrifying when the music video for the song dropped that June, featuring a naked wax figure of Taylor without her consent.

But the truth of what happened then didn't matter at the time, not when Kim Kardashian took to Snapchat to release what she claimed was an unedited call between Taylor and Kanye where she granted him permission to reference her by name in the song.

Taylor responded with a statement of her own that she shared on Instagram and Twitter, writing, "I wanted to believe Kanye when he told me that I would love the song. I wanted us to have a friendly relationship. He promised to play the song for me, but he never did. While I wanted to be supportive of Kanye on the phone call, you cannot 'approve' a song you haven't heard. Being falsely painted as a liar when I was never given the full story or played any part of the song is character assassination. I would very much like to be excluded from this narrative, one that I have never asked to be a part of, since 2009."

She ended up laying low for the rest of the year, and after all of that drama, who wouldn't have?

# reputation

# THE
# RISING
## FROM THE
# DEAD
## ERA

HELLO?!

With the release of *Reputation* came another really big chapter in my life. When I think of my first year of marriage and packing up our cozy rental house to move into the very first home my husband and I bought, I remember having this album on repeat in the background. It was a stressful year, but a happy one, and for once, Taylor and I were both in love at the same time. Of course, she was a presence at my wedding, too—not only did I walk down the aisle to an orchestra playing "Mine," but our first dance was to "You Are in Love" (thanks again for agreeing to that, Blake). Call me for all your Swiftie wedding-planning needs!

# THE DROUGHT WAS
# THE VERY WORST

Between Kim Kardashian posting that phone call on Snapchat to Taylor Swift announcing *Reputation,* just over thirteen months had passed, but it felt like an eternity. The Taylorverse wasn't totally silent during that time, though. She occasionally shared photos with friends on Instagram, she showed up for jury duty in Nashville, she released her song (and the accompanying music video) with Zayn Malik, "I Don't Wanna Live Forever," for the *Fifty Shades Darker* soundtrack. She performed a concert in Houston and reminded everyone to listen to her friends' new music when Lorde and HAIM released singles.

Still, this is a time that fans refer to as "the drought," and thinking back, it does really feel like there was radio silence from her, even if there actually

wasn't. For Taylor, someone who had become known for being accessible to fans, who was seen everywhere with everyone, this was a version of disappearing, and at that point, it wasn't clear if she was going to come back at all, let alone when.

Meanwhile, behind the scenes, Taylor had started a new love story and neglected to share the details with the class. But at this point in her life, after she had been so unceremoniously crucified for her dating habits (you know, the ones like many other single women in their twenties have), it seemed like that was exactly what she needed. She was dating Joe Alwyn, an actor with a British accent who lived in another country and who many people in the United States had never heard of before. Or

# How to Dress
## for the
# REPUTATION
## Era

**BLACK AND FOREST GREEN EVERYTHING**

**BLACK FISHNETS**

**BLACK SPARKLY BODYSUIT**

**SNAKE ACCESSORIES— ESPECIALLY A SNAKE RING**

**BLUE FLAPPER DRESS LIKE TAYLOR WEARS IN THE "DELICATE" MUSIC VIDEO**

since, really. This broke a pattern; this was different for her.

Unlike her relationships before, including her short-lived one with Tom Hiddleston (really, you're telling me that Loki wore that "I [heart] T.S." T-shirt of his own accord?), Taylor chose privacy. They could get to know each other without the noise of the outside world getting in the way (at least, as much as they could when she's the most famous person in the known universe), and as she would later reveal in her music, she found that he was someone who loved her at her lowest, even when it seemed like the whole world was against her.

During this time, she was also doing something even more important: fighting—and winning—a sexual assault trial.

After a member of Taylor's security team accused radio host David Mueller of groping Taylor during a 2013 meet and greet, the station he worked for fired him.

This led to Mueller suing Taylor, claiming that he was innocent. Taylor countersued for sexual assault for a grand total of one dollar, leading to a jury trial that played out over the course of a week in Denver, Colorado.

Even though Taylor was virtually unreachable at this point, fans wouldn't be stopped from showing her their support. Women who worked in the office building across from the courthouse where the trial was being held used Post-it notes to send encouraging messages. Sticking them to the window where Taylor and Joe could hopefully see them, they spelled out words and phrases like "fearless" and "haterz gonna hate," just so she would know she had people in her corner close by.

On August 17, 2017, a jury unanimously found in Taylor's favor.

On August 18, 2017, all her social media accounts went dark.

# THERE WILL BE NO EXPLANATION. THERE WILL JUST BE REPUTATION.

To fully understand the lore of *Reputation*, you first have to understand the feud between Kim Kardashian and Taylor Swift.

Well, that's not totally true, because there really is no understanding that one, and as a longtime *Keeping Up with the Kardashians* viewer and self-proclaimed Kardashian expert, I have a feeling that if she had it to do over again, Kim would probably do things a bit differently and choose not to edit *or* post that recording

(and so vehemently defend her now ex-husband), but I digress.

When Kim first shared the recording on Snapchat on July 17, 2016, it really did seem like everyone was turning against Taylor because of it—at least, on the internet, it did. #TaylorSwiftIsOverParty quickly became a trending topic, and the comments on Taylor's Instagram photos were flooded with the snake emoji after Kim called her one in a snarky subtweet about National Snake Day. Kim's tweet was a bit over-the-top for the situation, but again: I digress.

The snake symbolism is what's most important here, because a few days after Taylor's social media blackout, that's exactly what started to appear on her Instagram feed. Starting on August 21, 2017, our petty queen shared a video of a snake in three parts, starting with the tail and ending with a head that looked ready to snap.

Next came the album announcement in the form of three more Instagram posts that included the album cover, the November 10 release date, and the news that the first single would be dropping the following night. No captions. No additional information.

But by the time "Look What You Made Me Do" was finally here, it was more than clear what the vibes were going to be. This era was going to be darker and moodier than the ones in the past, and Taylor was no longer going to allow Kim, Kanye, or *any* of her haters to make her feel small.

And there would be more snakes. Lots of them.

In keeping with the theme of *Reputation*, Taylor kept the promotion of this album to a minimum. She wouldn't be doing interviews. She wouldn't be appearing on talk shows. She would let the album speak for itself, and basically, what the album said was, "I will be vindicated, and also, I'm in love."

She would later explain this decision in a 2019 interview with Apple Music's Zane Lowe: When she said, "There will be no explanation. There will just be *Reputation*," she meant it.

"I didn't go back on it. I didn't try to explain the album because I didn't feel that I owed that to anyone," she said. "There was a lot that happened over a couple of years that made me feel really, really terrible. And I didn't feel like expressing that to them. I didn't feel like talking about it. I just felt like making music, then going out on the road and doing a stadium tour and doing everything I could for my fans."

At face value, *Lover* may appear to be the quintessential Taylor Swift love album, but if you actually listen to it, it's more about anxiety than anything

# FAN ENCOUNTER

When longtime fan and social media personality Alex Goldschmidt decided to pop the question to his now-husband, Ross Girard, Taylor performed at the couple's engagement party—a surprise that he says was totally her idea. Though he and Taylor had met and talked before (and she had even invited him to participate when she performed "Blank Space" on *The Voice*), he wasn't sure if they'd be in contact again after she unfollowed everyone during the *Reputation* era ... but she proved she was still listening.

> "When I decided to propose to my now husband, I was listening to 'King of My Heart' in my car and I just thought that she'd like to know a deep cut from that album changed my life. I knew she went through a lot and people probably always talk to her about the same singles," Alex says. "And to be clear, I never asked her to perform! That was her idea! She has always been so genuine and kind to me from our DMs about love when I was wine drunk and sad to including me in her performance of 'Blank Space' on *The Voice*."

# IN THE TRENCHES

**B**y now, you've probably noticed that being a fan of Taylor Swift means that you're going to end up defending her at least once (and if you became a fan before *Reputation*, you probably defended her like it was your full-time job in 2017). One minute, you're watching videos on TikTok, and the next minute, you're sucked into the comments section where someone is sharing their extremely wrong opinions about Taylor Swift. Before you know it, you're part of an internet brawl, and you're determined to win.

The good news? Taylor's trolls always have the same tired criticisms, which means it's easy enough to know how to defend our girl when the moment presents itself. And just in case you end up in a tight spot, here's a cheat sheet for next time.

| THE TROLL | THE RESPONSE |
|---|---|
| **She can't sing.** | Really? Have you ever heard "Don't Blame Me" live? Are you sure we're talking about the same person? |
| **All her songs sound the same.** | You know what, you're right. I always dance to "Paper Rings" exactly how I dance to "My Tears Ricochet." |
| **Hasn't she dated, like, everyone?** | That's a really weird thing to say. |
| **She only writes songs about her relationships.** | Yeah, she does write songs about her relationships—just like every other artist in the history of music. But she also writes songs about dressing for revenge, her mom's battle with cancer, being her unique self, wishing she'd never grow up, the magic of karma, shaking off what the haters say about her . . . |
| **She ruined NFL football for fans.** | Did she ruin football, or did she help make football more accessible to new fans? |
| **There's just something about her that I don't like.** | Is it that she's a woman? I think it's that she's a woman. |

else. *Reputation* is the real love album of this time in Taylor's career. Not only was she falling in love with Joe, but she was also falling back in love with herself as she learned to stand on her own two feet and rise above what people thought about her.

She also seemed to find a new way to express herself in the midst of all of this. With the release of the physical album came two magazines, each filled with photos and album lyrics. *Reputation* would be the first of Taylor's albums that didn't come with secret codes to unscramble in the liner notes—she really was serious when she said there would be no explanation.

That was disappointing, but Taylor made up for it by sharing pieces of herself in another way. Each magazine also came with a poem that Taylor had written, giving the world a peek at her inner thoughts during this time. She'd been busy analyzing the way the public saw her, trying to figure out why she could never seem to do or say the right thing, but in the process, she seemed to come to the conclusion that it had all happened for a reason: "Without your past, you could have never arrived—so wondrously and brutally, by design or some violent, exquisite happenstance . . . here."

The fact that Taylor came back with her fangs out had fans excited (especially now that they had some idea of what had been going on during her social media silence), but not everyone felt that way. Though *Reputation* sold two million copies in its first week and made fans happy in the process, more than a few critics panned the album.

"If *1989* was a pleasant totalitarian regime, *Reputation* is a dictator too dumb to even do authoritarianism right. The album is as embarrassing as it is garish, like gold curtains in the Oval Office. Perhaps a reflection of a wider cultural problem, this Taylor sounds both expensive and empty," Geoff Nelson wrote in his review for *Consequence of Sound*.

Is anyone else's blood boiling, or is it just mine?

Fortunately, everything that Taylor had faced didn't stop her from keeping her arms wide open to her fans. She still held Secret Sessions before the release of *Reputation*, and she was just as genuine and warm to fans who met her in the Rep Room on tour.

One fan, Dina, who was chosen for Rep Room along with her friend Erika, says she was "hysterical" as she entered the area after her concert. The room was decorated with snakes, past tour costumes, and of course, the throne she sat in for the "Look What You Made Me Do" music video—Taylor *does* love a theme.

"Even as the biggest pop star in the world, she took her time and listened to our stories, genuinely listened and engaged with us—and made us feel like we were her best friends," Dina says.

As much as Taylor thrives on setting records and earning glowing reviews, looking back, it's clear that this album was very much for the fans, even if that's not what Taylor originally intended it to be. Though her relationship with her Swifties was quickly changing and becoming a bit more distant and less personal, she was still willing to let us in on her secrets—and in the case of *Reputation*, we seemed to be the only ones who knew how to understand what she was trying to say.

Whatever hold Kim and Kanye and their snake emojis had over Taylor—maybe even since that night at the VMAs in 2009—that was something she was setting herself free from, but not without first looking back at all the versions of herself that had led her to this fork in the road.

# THE OLD TAYLOR CAN'T COME TO THE PHONE RIGHT NOW

2017 was a weird time to be a Taylor Swift fan. It was also a time in which it was very much *in* to be anti-Taylor. People saw "Look What You Made Me Do" as yet another instance where Taylor was playing the victim. A lot of people felt vindicated by the Kanye phone call recording; they'd searched for a solid reason to hate Taylor, and now they finally believed they had one. And then there were the truly unimaginative haters who kept bringing up the men she'd dated, as if that meant anything at all about who she was as a person or an artist. But then again, Taylor said it herself years earlier: "Haters gonna hate."

And unfortunately, as Taylor would probably attest, those haters can be *loud*. If someone found out you were a die-hard Swiftie, whether it was in a conversation or seeing a Taylor-related post you shared on social media, it would make them even louder. For many, hating Taylor Swift became a character trait.

But as frustrating as it was to be a fan during this time, it also makes the *Reputation* era special to Swifties who have hung in through it all. This might not have been the album that earned her the critical

acclaim she has always chased after, but die-hard fans *really* got it.

Those fans are the ones who watched videos of Taylor eating cooking dough playing on mute, over and over again, in the weeks leading up to the *Rep* tour sales, just hoping to get a boost in your position in the Verified Fan line for pre-sale codes. Those fans are the ones who embraced the snake, got all dressed up for the tour, and might have even been chosen to meet Taylor in the Rep Room. And those fans are the ones who listened to "Look What You Made Me Do" and actually heard Taylor the first time. She wasn't playing the victim. She had internalized the criticism that everyone, Kim and Kanye included, had made against her during that dark period of time in 2016, and she was laying who she used to be to rest in favor of being someone new—maybe even someone who cared a little less what people thought of her.

"It actually started with just a poem that I wrote about my feelings, and it's basically about realizing that you couldn't trust certain people, but realizing you appreciate the people you can trust, realizing that you can't just let everyone in, but the ones you can let in, you need to cherish," she said at an iHeartRadio album release party.

There may not have been secret codes in the liner notes this time around, but the music video for *Rep*'s lead single left plenty of Easter eggs for fans to find. From the Nils Sjoberg tombstone to the dollar bill in her bathtub of diamonds to symbolize her win in the sexual assault trial against David Mueller, there was plenty to read into here *if* you knew what you were looking at. If you didn't, you might not understand the genius of the song—but finally, for the first time, it seemed okay with Taylor if she was misunderstood. She knew her truest fans would get it.

This was also the first time Taylor truly recognized the eras of her career in a tangible way—at least, in the same way that her fans had been acknowledging them all along. Taylor played different versions of herself in the video, all of whom joined her at the end of the video, wearing iconic outfits from each era, behaving in ways that Taylor was criticized for during that time. There was *Fearless* Taylor in her Junior Jewels T-shirt, getting called out for pretending to look surprised all the time, and even 2009 VMAs Taylor, holding a Moonman award and declaring that she'd like to be excluded from this narrative. The whole gang was there, and it showed a level of self-awareness that Taylor's critics had been convinced she simply didn't have.

*Rep* may not have gotten the Grammy buzz she was hoping for, and seeing

Taylor tear up as she announced that she'd just have to "make a better album" in her Netflix documentary *Miss Americana* is almost enough to make viewers tear up themselves. But this era did strengthen her bond with her fans, because by the end, we all survived together. Taylor had been hated on for being herself, but she was still here, and we had been hated on for supporting her, but we were still here, too.

And in 2020, the Kim and Kanye situation sorted itself out when the full call leaked online from an unknown source, showing that Taylor actually had been telling the truth the whole time. How's that for karma?

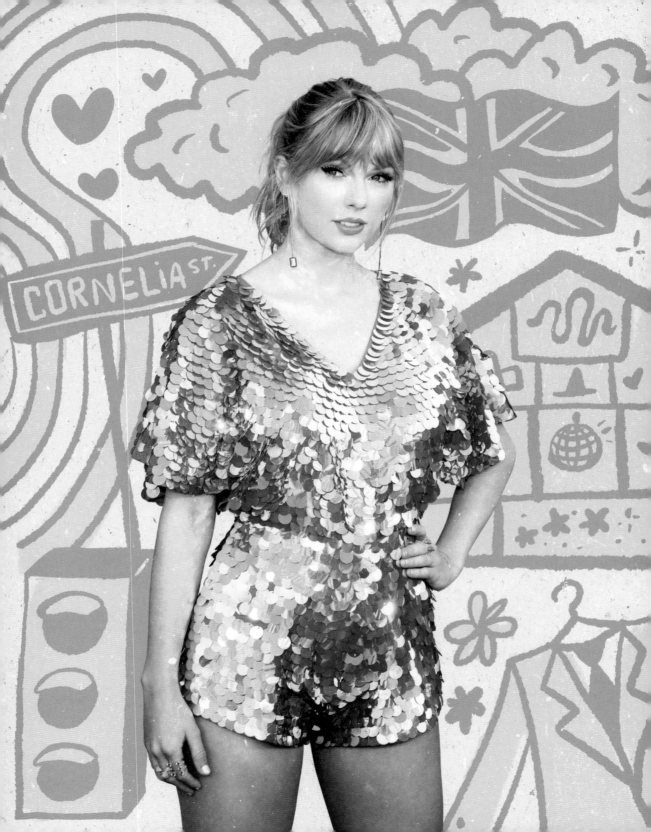

# Lover

## THE UNHINGED ERA

13

I will always look back on 2019 as one of my favorite years ever. I turned thirty, finally feeling confident and happy in my own skin, and I found out I was pregnant with my first child, about one month after *Lover* hit stores. I spent the beginning of my pregnancy listening to the album and planning which lyrics I'd use when sharing photos of my baby-to-be—cheesy, I know, but nothing seemed more perfect than this era's cotton candy aesthetic to celebrate this time in my life.

# IN OUR UNHINGED ERA

Maybe it was all the Easter eggs that Taylor scattered through the music videos released during the *Reputation* era, but by 2019, fans were on *alert*, looking for her to drop a hint that the next album was on the way.

To follow Taylor's career is to know that she loves following patterns and doesn't deviate from them except when absolutely necessary (like in the case of the extended break between *1989* and *Rep*). Her album pattern, up to this point, had always been to release something new every two years, and though she had deviated from that a bit with *Reputation*, fans assumed that she'd get back on track with the next album.

Then her Instagram aesthetic started changing—something so immediately noticeable that it was impossible to think it didn't mean something. As soon as the new year began, she shifted from posting photos that were dark and broody, full of blues, blacks, grays, and greens, and turned to a more pastel palette.

In February 2019, the first photo with the *Lover* filter appeared on Taylor's feed—a photo of her posing the night of the British Academy of Film and Television Arts (BAFTA) Awards, where she cheered on then-boyfriend Joe Alywn and his cast, who were nominated for *The Favourite.* She was wearing a gown designed by Stella McCartney, who she would later collaborate with and mention in the song "London Boy."

Next there was a photo of her cat Meredith, which seemed normal enough, but the photo *after* is what had everyone putting on their detective hats. It was a photo of palm trees that Taylor had added stars to, captioning the photo with

# How to Dress
## for the
# LOVER
## Era

~~~~~~~~~

**PASTEL COLORS
(ESPECIALLY PINK
AND PURPLE)**

**SEQUIN
BLAZER**

**PINK GLITTER
HEART
AROUND YOUR
EYE**

**RAINBOW
PATTERNS**

**HEART-
SHAPED
EVERYTHING**

exactly seven palm tree emojis, which we *all* believed was the start of a countdown. This is Taylor Swift—she doesn't just arbitrarily caption an Instagram post with emojis. There's a reason for everything.

This theory was seemingly confirmed with the next post: Taylor sitting on the sixth stair on a spiral staircase. Countdown continued (or so we thought). Then the most famous of all: the photo of Taylor standing behind a fence that just so happened to have five holes in it. I don't even like to talk about it, but I have to, because this book is about Swifties, and this is perhaps one of the biggest moments in Swiftie history—at least where clowning is concerned. (*Clowning* means coming up with theories about Taylor Swift's future releases, tours, and other career-related excitement, knowing that your theories are probably going to be wrong but enjoying the act of gathering clues and being delusional with other like-minded Swifties anyway. We do it often around here.)

But there *were* five holes in the fence. It did look like a countdown, even if Taylor didn't agree with us, and it was true that she was hinting at something, even if the countdown ended up being all in our heads. By now, her Instagram had officially shifted to the *Lover* aesthetic, and soon she'd start adding butterfly emojis to some of her Instagram captions.

On April 13—because of course it was April 13—she started posting photos without much of an explanation, just a date: 4.26. Later, we'd find out that these were close-ups from scenes for the "ME!" music video. At this point, there was definitely something going on, probably related to a new album . . . we just didn't know what.

Then something strange began happening in Nashville. Street artist Kelsey Montague started to paint a pair of butterfly wings on a wall near the Gulch. This wasn't weird in itself; Montague was known for painting wings. This pair was different, though, and people began noticing that not only did the color scheme of the wings match Taylor's current aesthetic, but they were also embellished with symbols that seemed to hint at Taylor, including exactly thirteen hearts. Fans began to gather at the mural, trying to decide if she was going to show up—and remember, this was all on a hunch. But as it turned out, for once, we were right. On April 25, the day before "ME!" was released, she actually *did* show up at that mural and took photos with the fans who had been faithfully waiting there. After visiting that mural myself, just days later, I can confirm that it was even more gorgeous and awe-inspiring in person than it was in photos.

Though Swifties had clowned in the past and would live to clown again, this time we really showed off our detective skills. Not even Montague knew she was painting a mural that had been commissioned by Taylor; Swifties figured it out first.

The *Lover* era kicked off with more Easter eggs than fans knew what to do with . . . and we weren't always quite as on our game as we were with that mural. Taylor revealed that she'd hidden a bunch of clues about the next era in the "ME!" music video, including the album title, but it took far too long for someone to finally figure it out. (The word *Lover* was literally spelled out in neon in the video. An actual neon sign. How embarrassing that we went feral counting holes in a fence and missed this.)

She had even more fun with us in May 2019, when she posed for the cover of *Entertainment Weekly* in a denim jacket covered in pins that held clues about her upcoming album. For example, one of the buttons had the word *calm* on it, a nod to "You Need to Calm Down," and the entire cast of *Friends* was represented in six different pins, a reference

to "It's Nice to Have a Friend."

"I've trained them to be that way," she said of us, her devoted fans using Swiftie detective skills, in that interview. "I love that they like the cryptic hint-dropping. Because as long as they like it, I'll keep doing it."

It's good to know that our Head Mastermind in Charge is happy that we're willing to play along with her. Not only does it mean that we're streaming her music videos thousands more times than we would have otherwise in the hopes of picking up on new clues we might have missed, but it's also one way she can connect to Swifties from a distance, strengthening that fan-to-artist relationship like only Taylor has ever figured out how to do. She may be (a lot) more famous than she was in those early days of her career, but even though the way she interacts with fans had to change, she never stops making sure that connection is still there.

Five days before *Lover* was released that August, she posted the photo of her standing behind the fence again—the one that had truly started it all.

"Okay NOW there are five holes in the fence," she wrote.

BUILDING A LOVER HOUSE

With the release of *Lover*, the Easter eggs didn't end. The "Lover" music video was also full of them, including a piece of lore that Swifties really held on to: the *Lover* house.

The house in the video is inside a snow globe and looks similar to a dollhouse—very two-dimensional from the outside, with rooms that are each themed after a different color. Whether it was a coincidence or not, all these colors corresponded to the colors that represent each album era . . . except two.

But with a gray spiral staircase under a coppery brown stairwell to the attic, *Folklore* and *Evermore* fit right in, even though Taylor has said that those albums were born out of her pandemic boredom, which wouldn't happen until months later.

Taylor has never confirmed or denied the *Lover* house theory, but it's a fun one, especially since the house appeared again in the visuals for the Eras Tour as if it had been burned to the ground, like Taylor was saying goodbye to this chapter of her career as she moves on to what's next after the tour ends.

Speaking of tours, unfortunately, *Lover* didn't get one—not in the way that every album since *Fearless* had. When the tour announcement came around, Taylor shared that she had decided to do something a little different (or at least she tried to). She explained that since *Lover* felt like "open fields, sunsets, [and] summer," a festival setting was what she was after. So she planned Lover Fest East and Lover Fest West for the summer of 2020, with multiple shows at SoFi Stadium in California and Gillette Stadium in Massachusetts, along with a handful of international dates.

But in peak pandemic times, the summer of 2020 didn't go the way that Taylor or *any* of us planned, and Lover Fest never ended up happening.

Even though not all of the *Lover* era came together the way Taylor had planned, there's still a lot to love about it, especially once *Miss Americana* premiered on Netflix in January 2020. A documentary following Taylor's political awakening and the making of *Lover*? It was exactly what fans had been hoping for, especially since it gave us a very rare glimpse into her life with Joe Alwyn. Despite the fact that he seemed to be the one to inspire the songs on the album, we didn't know much about him at this point—or ever—other than what Taylor chose to share in the songs she wrote while they were still together.

We did know that this was Taylor's most significant relationship so far.

THE
BIGGEST
CLOWNING
MOMENTS
IN SWIFTIE HISTORY

When your fandom revolves around a blond woman who gets a kick out of using Easter eggs and other symbols to send coded messages for her fans to figure out, you end up overanalyzing everything she says and does—from the photos she shares on social media to the nail polish she's wearing when paparazzi snap her on her way to dinner. And while even a broken clock is right twice a day, Swifties aren't always so lucky in their detective work.

So let's talk about *clowning*: a word to describe those times when you're acting like a clown (or what many fans refer to as "putting on your clown makeup") to come up with elaborate theories that will probably turn out to be wrong. And we've been wrong a *lot*.

But maybe the real rewards of clowning were the friends we made along the way?

Here are some of our biggest clown moments so far (with, no doubt, plenty more to come in the future):

THE TOM HIDDLESTON THEORIES

Some fans were convinced that Taylor's relationship with Tom Hiddleston was actually for a music video they were filming together, especially after he was spotted wearing that "I [heart] T.S." T-shirt. (No, it was not.)

KARMA

A lost, orange-themed album that fans believe Taylor scrapped between *1989* and *Reputation* that is currently locked in the vault and may surface someday. After Taylor's song "Karma" on *Midnights* may or may not have been her way of showing she's in on the joke, it seems less and less likely that an actual *Karma* album exists.

"THERE ARE FIVE HOLES IN THE FENCE!"

Literally the number of holes in a fence that Taylor stood in front of before she announced *Lover* that fans believed was signaling some sort of countdown. Reader, we were wrong again.

KALEIDOSCOPE

When Taylor told fans she hid the album title for *Lover* somewhere in the music video for "ME!" some serious investigating went down. After everyone was absolutely convinced that the title was *Kaleidoscope* and the case had been cracked, we found out it was actually *Lover* . . . you know, the word prominently featured in the video in the form of a bright pink neon sign.

WOODVALE

After some fans received *Folklore* albums with the word *Woodvale* printed ever so lightly in the background of the album art, they were convinced that it was a clue that a third sister album called *Woodvale* was on the way. But as Taylor explained during an appearance on *Jimmy Kimmel Live!*, it was actually the code name that she used for *Folklore* before it came out. Legend has it some Swifties are still waiting for the release of *Woodvale* today. (It's me, Swifties.)

THE CURIOUS CASE OF THE UPSIDE-DOWN PHONE

During Taylor's TikTok series, "Midnights Mayhem With Me," which she used to reveal the track listing for *Midnights* one by one, she spoke each track title into a rotary phone handset. But when she revealed two of the titles—"Anti-Hero" and "Vigilante Shit"—while holding the phone upside down, fans were convinced this meant something, like she was denoting two tracks that had features or would both get music videos. Ultimately, the upside-down phone meant nothing . . . or did it?

THE *REPUTATION* (TAYLOR'S VERSION) ANNOUNCEMENT THAT WASN'T

In the hours leading up to the Grammys in February 2024, Taylor's website went dark, with scrambled words left in a fake error code for fans to decode, right around the time that she changed her profile photo to black-and-white . . . and showed up on the red carpet in a black-and-white outfit. We were all convinced that this meant she was announcing *Reputation (Taylor's Version)*, but instead, she totally blindsided us with a brand-new album, *The Tortured Poets Department*.

They'd been together for about three years at this point, and she was outwardly admitting that she'd marry him with paper rings and referring to him as a "magnetic force of a man" . . . it seemed like a done deal. And in *Miss Americana*, we got to see scenes that he was involved in, but he was usually behind the camera, and we didn't get to see his face. If you weren't already a fan, you probably wouldn't have even known that the guy in the documentary was Joe Alwyn.

At the time, that kind of relationship seemed to be exactly what Taylor needed. After being ridiculed for her dating habits—both real and imagined by the general, misogynistic public—she was able to fall in love without the world watching, and what we knew of her relationship with Joe was what she chose to share with us. Based on what she revealed, fans quickly fell in love with him, because how do you not fall in love with the man who inspires your favorite artist to rhyme the word "rugby" with "pub we"?

Plus, once in a while, he'd share a photo of one of Taylor's cats on his Instagram Stories, and personally, I couldn't risk missing out on that. I had never heard of this man before in my life, but if Taylor liked him, so did I—and that meant that a lot of Joe's online following was suddenly made up of Swifties.

All of the pieces of Taylor's life seemed to be coming together during the *Lover* era. She'd found her voice and began speaking up for her political opinions and standing up for what she believed in, including the rights of the LGBTQ+ community. She seemed to have found the love of her life. She adopted a new cat, Benjamin Button. She was planning her summer concerts. She was collaborating with Stella McCartney on her merchandise.

Yet there were two black clouds over all this excitement, and their names were Scooter Braun and Scott Borchetta. Since *Lover* was her first album with Republic Records, it was also the first album that she owned outright; she left her masters to Big Machine Records when she chose to sign with another label when her contract was up at the end of 2018.

Taylor didn't know that when she walked away, her masters would be sold to someone who she said has made her the target of "incessant, manipulative bullying" for years. In June 2019, Taylor took to Tumblr to explain what was happening to her fans, calling the situation her "worst-case scenario." She wrote:

"This is what happens when you sign a deal at fifteen to someone for whom the term 'loyalty' is clearly just a contractual concept. And when that man says 'Music has value,' he means its value is

beholden to men who had no part in creating it. When I left my masters in Scott's hands, I made peace with the fact that eventually he would sell them. Never in my worst nightmares did I imagine the buyer would be Scooter. Any time Scott Borchetta has heard the words 'Scooter Braun' escape my lips, it was when I was either crying or trying not to. He knew what he was doing; they both did.

Controlling a woman who didn't want to be associated with them. In perpetuity. That means forever."

Fans were horrified that this could happen to someone, let alone an artist as powerful as Taylor Swift. This situation rocketed Scooter and Scott straight to the top of the Swiftie Shit List, even after Scott claimed that Taylor chose to walk away from her masters on her own.

"This is what happens when you sign a deal at fifteen to someone for whom the term 'loyalty' is clearly just a contractual concept. And when that man says 'Music has value,' he means its value is beholden to men who had no part in creating it. When I left my masters in Scott's hands, I made peace with the fact that eventually he would sell them. Never in my worst nightmares did I imagine the buyer would be Scooter."

Taylor didn't give up, just like she didn't give up when she got interrupted on that VMAs stage. Once again, she took something objectively terrible that happened to her and used it to fuel the next stage of her career. As we know now, what she was able to create out of the loss of her original work, her re-recorded albums, would not just become

a big part of her legacy, but also would be transformational for the music industry in general.

In *Miss Americana*, Taylor said that *Lover* is "probably my last opportunity to grasp onto that kind of success" she'd been hoping to accomplish. But fans knew that wasn't true, and less than a year later, Taylor would find that out for herself.

A GUIDE TO TAYLOR SWIFT'S CATS

In the wise words of a blond woman we all know and love: "Three cats is a cat lady, but two cats is a party." And Taylor Swift is most definitely a cat lady. These days, she's a mom to three gorgeous cats . . . even if one of them seems a bit more destined for the spotlight than the others. Here's what you need to know about Meredith, Olivia, and Benjamin.

MEREDITH GREY SWIFT

NAMESAKE: Meredith Grey from *Grey's Anatomy*, played by Ellen Pompeo

BREED: Scottish Fold

ADOPTION DATE: 2011

CLAIM TO FAME: Meredith is Taylor's first cat (and also her grumpiest). After she gave Taylor a nasty scratch in 2015, Taylor joked that she now owed her $40 million after news reports claimed that's how much her legs were insured for.

FUN FACT: Despite the fact that Meredith's mother is one of the most famous people on Earth, she hates having her picture taken.

OLIVIA BENSON SWIFT

NAMESAKE: Olivia Benson from *Law & Order: Special Victims Unit*, played by Mariska Hargitay

BREED: Scottish Fold

ADOPTION DATE: 2014

CLAIM TO FAME: After appearing in music videos like "ME!" and "Blank Space," along with TV commercials (like the one for Diet Coke where she starred alongside her mom), Olivia's net worth is an estimated $90 million.

FUN FACT: Her nickname is Dibbles.

BENJAMIN BUTTON SWIFT

NAMESAKE: Benjamin Button, from *The Curious Case of Benjamin Button*, played by Brad Pitt

BREED: Ragdoll

ADOPTION DATE: 2019

CLAIM TO FAME: Taylor adopted him when he starred in the "ME!" music video, where it was love at first sight.

FUN FACT: He appeared on the cover of *Time* with Taylor when she was named Person of the Year in 2023.

folklore

THE CARDIGAN ERA

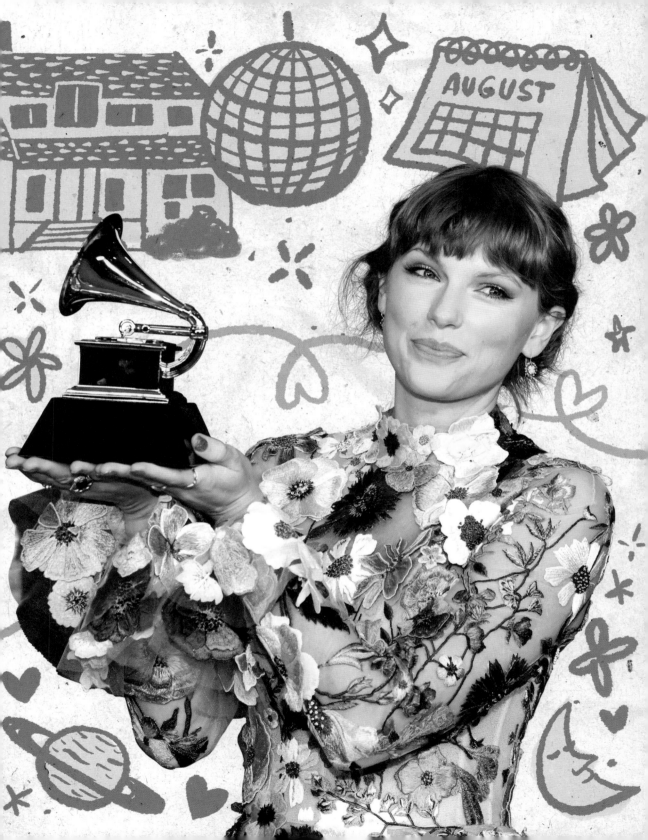

Fans who have been around a while all remember where they were when Taylor revealed she was dropping a surprise album in July 2020. I was on the couch, sitting beside my newborn daughter, Penelope, so sleep-deprived that I thought I was hallucinating the Instagram post of the *Folklore* cover. The album quickly became the soundtrack to the early weeks and months of motherhood . . . and *the only* thing that would get the baby to stop crying during her witching hour. As soon as Penelope heard the opening notes of "The 1," she'd immediately go silent. Born into Swiftiedom, she somehow knew from birth that when Taylor is singing, you listen.

I'M DOING GOOD,
I'M ON SOME NEW SHIT

Over and over again, Taylor has proven just how important the element of surprise has always been to her and in her relationship with her fans, but in many ways, she is a creature of habit. After watching her (and her artistry) grow from her teenage years into her thirties, it's easy to see that there are a few things that truly matter to her on the business side of each album cycle. She's all about deluxe versions, album extras, and alternate covers—anything to help her break sales records. If you haven't noticed, Taylor *loves* breaking sales records.

Usually, breaking those records requires plenty of promotion. People—not just your die-hard fans, but people in general—need to know that you have a new album coming. And those physical albums and records usually need to be in production so that people will buy them both online and in brick-and-mortar stores.

Knowing all this and following Taylor's career closely for more than a decade before *Folklore* came out, I would have never guessed Taylor would release a surprise album. Even though Beyoncé pulled it off so flawlessly with *Lemonade*, it just didn't seem like something Taylor would do.

But in the summer of 2020, one of the heaviest, most-challenging years of just about everybody's life, she managed to pull off a surprise album, and I've never been so glad to be wrong.

It was still the early hours of the morning on July 23 when black-and-white images began showing up on Taylor's Instagram account, one after the other.

Nine images and a few minutes later, we had our explanation: her eighth studio album, *Folklore*, would be released at midnight.

"Before this year, I probably would've overthought when to release this music at the 'perfect' time, but the times we're living in keep reminding me that nothing is guaranteed. My gut is telling me that if you make something you love, you should just put it out into the world. That's the side of uncertainty I can get on board with."

Folklore offered fans a unique opportunity that had never come with any other album thus far: the chance to go in completely blind. For the first time, there was no single that might hint at what the album would sound like, no music video to analyze, no Easter eggs to hunt for and decode. Instead, when the clock struck midnight on July 24, 2020, we pressed play and discovered the world of *Folklore* at the same time.

As with all relationships, things can grow a bit stale and boring if you stop surprising each other, if you know everything there is to know about each other. But *Folklore* was proof that, no matter how well we thought we knew Taylor, no matter how predictable and readable some of us might have thought she had been, she was still completely capable of pulling off a surprise like this.

The music itself was surprising. While all the hallmarks of Taylor's music that Swifties have grown to love and hold so close over time are present in *Folklore*— her storytelling, the relatable emotions that go into her lyrics, the way you can tell how meticulous she is with every detail of every song—it still sounded like something new and unexpected. And while Jack Antonoff's footprint was on this album, working with new collaborators like Aaron Dessner was the perfect way to keep things fresh.

"Before this year, I probably would've overthought when to release this music at the 'perfect' time, but the times we're living in keep reminding me that nothing is guaranteed. My gut is telling me that if you make something you love, you should just put it out into the world. That's the side of uncertainty I can get on board with."

How to Dress
for the
FOLKLORE
Era

- CREAM-COLORED CARDIGAN
- NEUTRAL COLORS
- FLOWY, BOHO STYLE
- PIGTAIL BUNS
- COTTAGE-CORE DRESSES AND SKIRTS

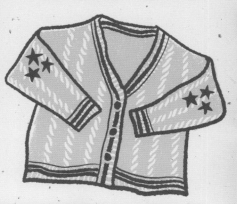

The genre switch to alternative for *Folklore* brought in a lot of new fans, whether they were people listening to Taylor for the first time or fans who had drifted off somewhere along the way and decided to return to her music. Taylor finally seemed to be earning musical credibility from those who weren't able to see that she deserved it all along until it was packaged in a way that slapped them in the face with her talent.

The influx of fans brand-new to Taylor's music meant that those who usually listened to the indie/alternative genre suddenly started paying attention to her. Fans of Bon Iver were curious enough to listen to "Exile." The critical acclaim that this album earned almost immediately, along with the mystery behind the surprise drop that had everyone talking, didn't hurt, either, widening her appeal in a way that's almost impossible for an artist to achieve this far into their careers. If anyone thought that she'd already shown all the tricks she had up her sleeve nearly ten albums in, they were wrong. *Folklore* alone proved that the best of Taylor Swift could still be yet to come.

And that's exactly what she proved at the 2021 Grammys, when *Folklore* cinched her third Album of the Year award.

PASSED DOWN LIKE FOLK SONGS

Even though Taylor managed to surprise us with *Folklore*, fans still knew her well enough to know which songs on the album were likely at least a little autobiographical. There was "My Tears Ricochet," which seemed to so clearly point to how Taylor felt about the sale of her masters, alongside "Invisible String," which included very specific details about her relationship with Joe. Meanwhile, "The Last Great American Dynasty" wasn't just motivated by Taylor's life; it was also inspired by Rebekah Harkness, the woman who owned Taylor's Rhode Island home before she died. After marrying her second husband, Standard Oil heir William Harkness, in 1947, Rebekah became a socialite, nicknaming their Watch Hill home Holiday House. She was known for throwing wild parties there with famous guests like Andy Warhol and J. D. Salinger, and legend has it that she once filled their swimming pool with Dom Pérignon. She and William (or Bill, as Taylor refers to him in the song) were married for less than a decade before he died in 1954, but Rebekah continued living there and maintaining her reputation

RECORDS BROKEN

BY TAYLOR SWIFT

She was the first artist to win the Grammy Award for Album of the Year four times.

• • • • • •

She was the youngest artist to ever win Album of the Year (*Fearless*).

• • • • • •

Fearless was the most awarded album in country music history.

• • • • • •

She is the only artist to ever claim all Top 10 spots on the Billboard Hot 100 at the same time.

• • • • • •

She was the first woman to ever replace herself at number 1 on the Hot 100 chart.

• • • • • •

"All Too Well (10 Minute Version) (Taylor's Version)" is the longest song in history to reach number 1 on the Billboard charts.

• • • • • •

She has achieved the most number 1 albums on the Billboard 200 by a female.

• • • • • •

She is the artist with the most American Music Awards in history—40 and counting.

• • • • • •

The Eras Tour is the highest grossing tour of all time.

• • • • • •

of being the loudest woman Watch Hill had ever seen.

The thing about dyeing the neighbor's dog key lime green? As the story goes, she actually did that, along with pulling other hijinks, like filling the fish tank with scotch and dressing up as a waitress during her own parties so she could eavesdrop on her guests and find out all the good gossip. (Can we blame her for that one?)

Rebekah died in 1982 at the age of sixty-seven, and her ashes were kept in a $250,000 urn designed by Salvador Dalí. Naturally.

It's easy to see why Taylor would have felt a kinship with Rebekah. When she first purchased the home in 2013 for $17.75 million, she angered local residents because of the paparazzi and attention she attracted to the area, and things didn't get much better when she built a seawall to fix erosion damage. Though it was on the part of the beach behind the home that was privately owned, her neighbors didn't care; they accused her of making it harder to access the public area of the beach.

If Taylor was bothered by this, she didn't show it. Instead, she lived the way Rebekah would have and used the home to throw the epic Fourth of July parties she was once known for until she started to keep things more

low-key leading up to the release of *Reputation*.

And then there was the teenage love triangle. Starring a cast of characters named after Blake Lively and Ryan Reynolds's three eldest children, James, Inez, and Betty, Taylor managed to weave a story about a boy who cheated on his girlfriend over the summer, only to beg for her back when he shows up at her party with his tail between his legs.

In the introduction to the album, Taylor wrote, "In isolation my imagination has run wild and this album is the result, a collection of songs and stories that flowed like a stream of consciousness. Picking up a pen was my way of escaping into fantasy, history, and memory. I've told these stories to the best of my ability with all the love, wonder, and whimsy they deserve. Now it's up to you to pass them down."

While, as usual, fans would analyze the lyrics of this album's songs for clues about Taylor's life, this time the fictional stories she was telling were being analyzed, too, as we tried to piece together the details to make sense of it all. Some fans theorized that the album was telling one complete story, though out of order. Some believed "Hoax" signaled trouble in Taylor's relationship with Joe. As always, the album took on a life of its

own, becoming something new to each person who listened to it.

Eagle-eyed fans who analyzed the album credits also noticed an unfamiliar name among them: William Bowery, who was given songwriting credits on "Exile" and "Betty." After a little sleuthing, it seemed clear that this was a pseudonym for Joe Alwyn; the Bowery Hotel was a place that he and Taylor frequented early in their relationship, while William was the name of Joe's great grandfather.

This was confirmed in the Disney+ documentary *Folklore: The Long Pond Studio Sessions*, where Taylor also dove into her storytelling process while drinking wine and chatting with Aaron and Jack.

It was during these conversations that she revealed that, ultimately, her goal with the album was to bring people hope during a pretty hopeless time.

"It kind of is the overarching theme of this whole album, of trying to escape, having something you want to protect, trying to protect your own sanity, and saying, 'Look, they did this hundreds of years ago. I'm not the first person who's felt this way,'" she said.

And even though she didn't mean to in that moment, she managed to voice why fans keep coming back: her lyrics always remind us that we're not the first person who felt this way. She has felt this, too. We are not alone.

THE SWIFTIE
READING
LIST

After nearly two decades of proving her talent, it's probably safe to say that Taylor Swift is a pretty solid songwriter. Not only are her lyrics relatable, but she always knows just how to invoke whatever feeling she's singing about in her listeners, and she manages to accomplish some of that by referencing literature.

Good writers are usually good readers, after all, and though Taylor isn't really one to share what's on her Kindle TBR, it's easy to tell what she's read and loved if you listen to her music. Here are the classic novels (and poems) that have inspired Taylor's music.

The Great Gatsby by F. Scott Fitzgerald	"This Is Why We Can't Have Nice Things," "Happiness"
Jane Eyre by Jane Austen	"Mad Woman"
A Tale of Two Cities by Charles Dickens	"Getaway Car"
Where the Crawdads Sing by Delia Owens	"Carolina"
The Scarlet Letter by Nathaniel Hawthorne	"Love Story," "New Romantics"
The Sun Also Rises by Ernest Hemingway	"Invisible String"
"Compassion" by Miller Williams	"Ivy"
"Tonight I Can Write" by Pablo Neruda	"All Too Well"
Alice's Adventures in Wonderland by Lewis Carroll	"Wonderland"
Rebecca by Daphne du Maurier	"Tolerate It"

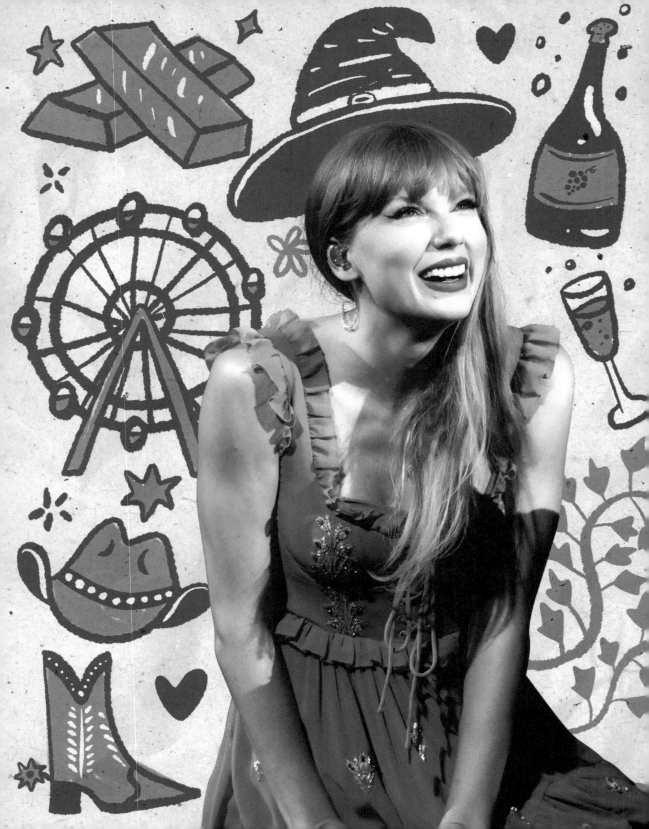

evermore

THE WITCHY ERA

If *Folklore* was the soundtrack to the earliest weeks of my motherhood experience, *Evermore* represents the time when I was finally getting the hang of it. It was all still so brand new, but it finally felt like Penelope and I were working together as a team, especially when I'd press play on "Champagne Problems" and her crying would instantly stop. She's much older now, but hearing *Evermore* never fails to help her fall asleep. Maybe Taylor should consider a lullaby album?

BACK IN THE FOLKLORIAN WOODS

The best (and maybe the only) time Taylor Swift could get away with surprising her fans with a *second* album drop was just five months after she surprised us the first time.

Of course, over the years we've learned to assume that Taylor does always have something up her sleeve at any given moment, and our Swiftie senses seem to be on high alert the closer we get to her December 13 birthday. This is someone who loves her birthday, and in the past she's celebrated it by sharing something new with us, like when she made the Eras Tour concert film available for streaming in December 2023 or when she released "Christmas Tree Farm" just a week before the big day in 2019. But when December 2020 rolled around, most of us were still trying to process *Folklore*, let alone think about another album of all new songs.

On December 10, photos began to show up on Taylor's Instagram grid without explanation, and as we waited for the full nine photo puzzle to come together to form a picture of Taylor wearing a plaid wool coat with a French braid down her back, it was obvious that she'd pulled one over on us again.

"To put it plainly, we just couldn't stop writing songs. To try and put it more poetically, it feels like we were standing on the edge of the folklorian woods and had a choice: to turn and go back or

How to Dress.
for the
EVERMORE
Era

- **FRENCH-BRAIDED HAIR**

- **LACE-UP BOOTS (BROWN OR BLACK)**

- **LONG DRESS PAIRED WITH A CLOAK (WITH A HOOD, OF COURSE)**

- **FLANNEL SHIRT OR COAT**

- **WARM COLORS, LIKE DEEP REDS, ORANGES, AND BROWNS**

to travel further into the forest of this music. We chose to wander deeper in."

She went on to explain how out of character this was for her, adding, "In the past I've always treated albums as one-off eras and moved on to planning the next one after an album was released. There was something different with *Folklore*. In making it, I felt less like I was departing and more like I was returning."

> "To put it plainly, we just couldn't stop writing songs. To try and put it more poetically, it feels like we were standing on the edge of the folklorian woods and had a choice: to turn and go back or to travel further into the forest of this music. We chose to wander deeper in."

Evermore was released as soon as the clock struck midnight on December 11, 2020, and it was official: *Folklore* had a sister, and the rest of us had an entirely new batch of music to work our way through.

When it came down to it, *Evermore* was all about Taylor staying connected to her fans during a time when she couldn't be with them in the ways that she was used to. As she wrote in the album's prologue:

"I wanted to surprise you with this the week of my 31st birthday. You've all been so caring, supportive and thoughtful on my birthdays and so this time I wanted to give you something! I also know this holiday season will be a lonely one for most of us and if there are any of you out there who turn to music to cope

with missing loved ones the way I do, this is for you. I have no idea what will come next. I have no idea about a lot of things these days and so I've clung to the one thing that keeps me connected to you all. That thing always has and always will be music."

It seems impossible that we didn't have songs like "Champagne Problems" before this album, but now it's widely regarded as one of her best—and one of her most fun to scream along with when she performs it live. This album would be her last new release before she started rolling out the rerecordings, and she certainly made it count. Just like with *Folklore*, she mixed some autobiographical storytelling with fictional stories she'd made up. While she probably didn't commit a revenge killing in real life the way

ARE YOU A FOLKLORE OR AN EVERMORE?

Taylor has been very clear about *Folklore* and *Evermore* being sister records. They have a lot of similarities, from the sound to the storytelling, but they do each stand on their own. These two albums are sisters, after all—*not* twins. They might share similar vibes, but side by side, these are actually two very different albums, and the one you relate to most says a lot about who you are.

Having trouble figuring out if you're more "Invisible String" than "Champagne Problems"? Read on.

If you're happier in the fall and winter than you are in the spring and summer . . . **you're probably *Folklore*.**

If you feel more hopeful than melancholy when you wake up each morning . . . **you're probably *Folklore*.**

If you're the eldest daughter . . .
you're probably *Evermore*.

If you prefer a cold glass of white wine (maybe even with ice) to a warm red . . . **you're probably *Folklore*.**

If you feel more nostalgic for your college memories than your high school glory days . . .
you're probably *Evermore*.

If you'd rather get up to watch the sunrise than stay out and watch the sunset . . . **you're probably *Folklore*.**

If you'd rather vacation in a cabin in the woods than at the beach . . . **you're probably *Evermore*.**

If it's chilly outside and you reach for a cardigan over a flannel . . . **you're probably *Folklore*.**

she sang about in "No Body, No Crime," the song "Long Story Short" sounded suspiciously like Taylor healing from everything that happened to her at the end of the *1989* era leading up to *Reputation*.

But even though *Evermore* is another example of what a talented singer-songwriter she is, as well as one more album that would serve to bring in new fans she hadn't been able to reach with her previous music, there were rumors that Taylor secretly hated *Evermore*. This wasn't total delusion on the fans' part—there were a few clues along the way that this album wasn't her favorite. She marked *Folklore*'s first anniversary with a social media post but ignored *Evermore*'s entirely. *Folklore* got its own Long Pond Sessions special, while *Evermore* did not. And *Folklore* was the album she campaigned (and won) for at the Grammys. Was she not as proud of *Evermore* as she was of its sister?

Taylor addressed the rumors during the opening weekend of the Eras Tour and said she wanted to shut them all down before she performed "Champagne Problems." "What is your evidence? I would like to see your evidence. You guys were like, 'She did not wish *Evermore* a happy birthday.' I don't even wish people a happy birthday on social media," she said while sitting at her piano. "But I'm here to dispel the rumors and prove wrong the allegations that I hate *Evermore* because I actually love that album and am so proud of it."

Since then, Taylor hating *Evermore* has remained an inside joke among the fandom, even though it's now pretty clear that she actually loves it. After hearing her singing the title song solo without Bon Iver in Cincinnati as a surprise during the tour and giving one of her best performances to date, there's no doubt about that.

WAIT FOR THE SIGNAL AND I'LL MEET YOU AFTER DARK

Evermore turned out to have a massive impact beyond just surprising fans with its release, including the way it even spawned new Eras Tour traditions.

One of the tracks on the album is called "Marjorie" and was written about Taylor's

grandmother, the late opera singer who died in 2003 at the age of seventy-four. During her life, Marjorie Finlay was known for her talent, much like her granddaughter eventually would be, hosting her own television show while

the family lived in Puerto Rico and performing on tour.

Marjorie's voice was used as backing vocals in the song that Taylor wrote with her in mind, and while it was surprising to see she included such a deeply emotional song on the set list at the Eras Tour, it became a meaningful moment at every show. I was there the second night of her Atlanta concerts, which was the first time the crowd decided to turn on their phone flashlights to illuminate the stadium while she sang the song—a gesture that brought Taylor to tears.

"How are you going to go and do that to me on a song about my grandmother who passed away?" she said onstage. "I just completely . . . like, my knees went weak, genuinely, like that physically . . . I physically felt them. That was so beautiful of you to do that."

From that night on, fans turned on their flashlights every time Taylor performed "Marjorie" as a tribute to someone who obviously meant so much to her, and it became part of the Eras Tour tradition.

Another tour tradition was born during the *Evermore* set: the cheers that happen after "Champagne Problems." This more low-key moment in the show lends itself well to a standing ovation—not to mention the fact that Taylor is plenty deserving of applause for playing piano and singing in the middle of a marathon set list—and the cheers seemed to go on longer and longer as the tour continued.

Sometimes, it would last for just a minute or so before Taylor would thank everyone and start speaking again, but on the last night of the first US leg of the tour at SoFi Stadium in Los Angeles, the cheer went on for more than seven minutes straight.

"I'm going to spend several decades trying to figure out words for how that just made me feel," she told the crowd.

This part of the evening also proved that Swifties are never living down the cult accusations, thanks to the witchy vibes that Taylor's "Willow" performance gives off. She and her dancers are all wearing cloaks, and the dancers are carrying yellow orbs as they make their way to the stage. Many fans joke that this is the "cult initiation" part of the evening, and some people online have taken that a bit too seriously.

While Taylor has always been the subject of weird rumors, what happened during "Willow" at the Eras Tour really brought out some brand-new, very creative ones. Some of her critics claimed that portion of the evening was actually Taylor dancing in a coven ceremony for witches, and her witchcraft is

MUST-WATCH TV AND MOVIES FOR SWIFTIES

᠅

Taylor Swift *definitely* has more than twenty-four hours in a day. Not only is she constantly cranking out new music, breaking records, and coming up with novel ways to hide Easter eggs in her social media posts and music videos, but somehow, she also has time to watch TV and movies like the rest of us do. Here are the ones she's said are her favorites:

GREY'S ANATOMY	THE WAY WE WERE
.
LAW & ORDER: SPECIAL VICTIMS UNIT	SENSE AND SENSIBILITY
.
KILLING EVE	LOVE ACTUALLY
.
SOMETHING GREAT	THE SHAPE OF WATER
.
	FRIENDS

actually how she's managed to gather so many dedicated fans.

This performance has garnered everything from warnings to mothers to protect their children's safety and avoid taking them to see Taylor perform to accusations that she's practicing black magic and intentionally using "satanic imagery" onstage to influence her fans. And her "Dancing Witch" remix of "Willow" definitely didn't help!

But like always, Taylor seems to be in on the joke. After a plane flew over the stadium in Buenos Aires just as Taylor sang about turning the plane around in "Labyrinth," the surprise song that night, she couldn't help but joke about the rumors. She posted a video of the moment on Instagram, writing, "never beating the sorcery allegations."

Taylor might have millions of fans and a career that's continued to burn bright even long past the stage when her peers' have gone out, but that's not witchcraft— she's just that good.

And if the Swifties are a cult? Well, maybe we're all okay with that.

Midnights

THE
SLEEPLESS
ERA

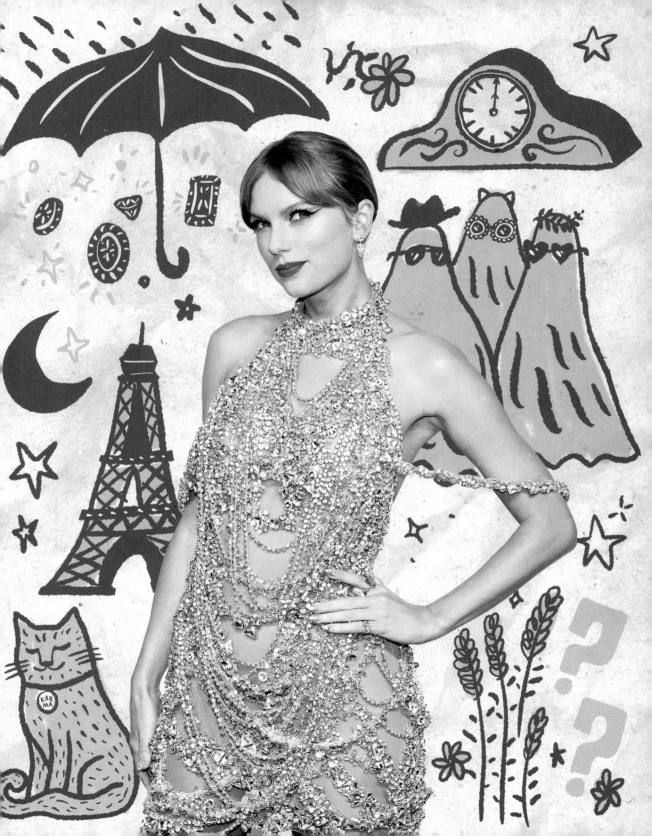

If I could describe the *Midnights* era in one word, it would be chaos, and that was truly the way my life felt at the time it was released, too. Finally having found my footing as a mother, I was still trying to figure out who I was as a person and feeling more lost than I'd ever been in my adult life. Listening to Taylor look back on the sleepless nights of her past made me do the same as I questioned what I wanted my future to look like and who I wanted to be outside of someone's mom—something that I think many people face after becoming a parent for the first time. On the other side of it now, I know Taylor helped me out of that rut just like she's done so many times before.

MEET ME AT MIDNIGHT

Topping two massively successful surprise albums wasn't going to be easy, but Taylor Swift has never had a problem outdoing herself. And when the time came to release her first all-new album after *Folklore* and *Evermore*, she created the most chaotic album roll-out to date, making her sleepless nights everyone's problem.

It all started on August 28, 2022, with the MTV VMAs—a historically significant award show for Taylor. When she showed up on the red carpet wearing that jewel-encrusted Oscar de la Renta dress, those of us watching from home were *sure* she was about to announce *Reputation (Taylor's Version)*. The dress was so reminiscent of the diamond bathtub scene from the "Look What You Made Me Do" music video that it seemed like a very blatant Easter egg.

But instead, when she took the stage to accept the award for Video of the Year for *All Too Well: The Short Film*, she had a different announcement to share.

"I know with every second of this moment that we wouldn't have been able to make this short film if it weren't for you, the fans. Because I wouldn't be able to rerecord my albums if it weren't for you. You embolden me to do that," she said. "I had sort of made up my mind that if you were going to be this generous and give us this, I thought it might be a fun moment to tell you that my brand-new album comes out October 21. And I will tell you more at midnight."

And with that, the *Midnights* era was up and running. As promised, when the clock struck midnight, the album's cover appeared on Taylor's Instagram account, where she explained that this

How to Dress
for the
MIDNIGHTS
Era

CELESTIAL PATTERNS

DEEP BLUES AND PURPLES

COLORFUL TINSEL JACKETS (LIKE THE "KARMA" JACKET)

'70S STYLE

ANYTHING AND EVERYTHING BEJEWELED

album would tell "the stories of thirteen sleepless nights scattered throughout my life." Just from seeing the cover, it was clear that this era would be very aesthetically different from what we've come to expect of Taylor, and in the *best* way.

We didn't know it yet, but over the next two months leading up to the album release, Taylor's fans would be in for a wild ride. Though many artists will simply announce their next album and maybe release a single or two and a music video to go with it leading up to the big day, that's never been Taylor's style. In a way that no other living artist has been able to do, Taylor turned her new album into a full experience, but it didn't just work because of how creative she is—it also worked because, for more than fifteen years leading up to this album release, she'd put in the time and the work to cultivate the kind of fan connection that meant that people of all ages were willing to lose sleep to participate in that experience.

Since the album was called *Midnights* and the theme was "things Taylor thinks about when she can't sleep," the entire rollout was based upon keeping her fans up late . . . and because this is Taylor, most of us were happy to play along (though there were a lot of complaints about being tired on social media during

this time, including many from me). As a member of the Swiftie club in her thirties and with a child, I do have to admit that I really could have done with more sleep (and a lot more coffee) during this era.

But still, even if we were tired at school or work the next day, it was totally worth staying up for the announcements and Easter eggs Taylor would drop at midnight along the way—all shared on TikTok. First came the special edition album covers, which came together to form a clock. Next there was a behind-the-scenes video of Taylor working on the album (with special guest Jack Antonoff . . . and her cats). Then the real fun began on September 21, when she introduced the TikTok series "Midnights Mayhem With Me" to introduce the track titles for the album. Themed like a seventies game show, each video featured Taylor sitting beside a bingo cage, and whatever number came out would be the track title she shared that day.

Watching these back now that Swifties know *Midnights* like the back of our hands, it's interesting to see the way Taylor reacted, finding out which track list she'd just pulled in each episode. From the giggles when she announced "Karma," knowing that fans have theorized that she will one day release an album with that title, to the way she opened the very first video with "It's

FRIENDSHIP BRACELET DECODER

Swifties have always had a habit of going big when they see Taylor performing live—after all, in her earlier tours, that's how we'd get noticed by a member of her team and be chosen for T-Party, Club Red, Loft '89, or Rep Room. Those days may be long gone, but when the Eras Tour began, so did a new tour tradition: creating friendship bracelets to trade with other fans at the concert, including total strangers. Then again, is anyone a stranger at a Taylor Swift concert?

The concept of trading friendship bracelets seems even more fitting when you consider how Taylor has built such a close relationship with her fans over the years. YouTuber Ally Sheehan, who is known for sharing her album reactions and Swiftie opinions with more than one hundred thousand subscribers, describes Taylor as "a shoulder to cry on" for her fans. "Taylor might be the most famous human alive right now, but she'll always feel like our older sister," she says. "Like maybe if she weren't so busy, we might go shopping together or drink wine and talk about heartbreak."

So it's no surprise that friendship bracelet exchanges have now become common anywhere Swifties happen to be, even when they're in the audience for the Eras Tour film at movie theaters worldwide. Though some feature lyrics from Swift's songs, others are harder to decode, especially for anyone new to the fandom (and especially when they include long and seemingly meaningless acronyms). But that's where this glossary comes in.

Read on to decode some of the most popular friendship bracelet phrases and acronyms used by fans during the Eras Tour (or use this list for inspiration while making your own).

YOYOK

This stands for "You're on Your Own, Kid," the song from *Midnights* that contains the lyrics that inspired the friendship bracelet trend in the first place.

TOTCCTTPRNWOCSD

"The old Taylor can't come to the phone right now. Why? Oh, 'cause she's dead" from "Look What You Made Me Do"

ATWTMVTVFTV

"All Too Well (10 Minute Version) (Taylor's Version) (From the Vault)," the fan-demanded lengthier version of her ballad "All Too Well" from *Red*

123LGB

"1, 2, 3, let's go, bitch," the chant that fans made up for Taylor's live performances of the song "Delicate"

DO U LIKE DEM

A fan once posted photos on Tumblr of stars that Taylor had drawn while autographing albums, asking what they were. Taylors reposted the photos, replying, "Stars do u like dem."

TIWWCHNT

"This Is Why We Can't Have Nice Things," a song from *Reputation*

NO ITS BECKY

This phrase comes from a meme featuring a photo of a teenage Taylor Swift, which fans joked was actually a girl named Becky. Taylor herself was spotted wearing a "no its becky" shirt in 2014.

SEEMINGLY RANCH

One Swift fan account on Twitter posted a photo of the singer at a Kansas City Chiefs game early in her relationship with Travis Kelce, describing one of the dipping sauces she had with her chicken tenders as "seemingly ranch," and the phrase quickly went viral.

YES, WHALE

In a video Taylor once shared on Instagram from a whale-watching trip, she yelled, "Yes, whale!" when she saw one jump out of the water, and the phrase became an inside joke within the fandom.

CHILD OF DIVORCE

A phrase used to describe people who are both Swifties *and* fans of Harry Styles, despite their breakup years ago

87

Travis Kelce's jersey number, which was seen on a friendship bracelet Taylor wore to a Chiefs game

SCTUPMITF

This acronym stands for "Screaming, Crying, Throwing Up, Punch Me in the Face," a viral TikTok audio that started with Taylor's "Blank Space."

WOODVALE

Swifties believed that a third album in the *Folklore* series was coming after the word *Woodvale* was seen printed on some of the albums, but Taylor claims that it was just the album's code name before it was released.

FHITF

This one stands for "five holes in the fence." While fans were eagerly examining all of Taylor's social media posts before the *Lover* album announcement, some were convinced that a picture of her standing in front of a fence was a clear indicator that something was coming in five days, because there were five holes in the fence.

STARBUCKS LOVERS

One of the most commonly misheard lyrics is "Starbucks lovers" instead of "star-crossed lovers" in "Blank Space," and fans who actually are Starbucks lovers have run with it.

OLIVE GARDEN

The place where Taylor and Este meet up for dinner every Tuesday night in the song "No Body, No Crime"

SLUAUFH

"She's laughing up at us from hell," a line from "Anti-Hero" from *Midnights*

me, hi"—the lyrics to "Anti-Hero" that we didn't know yet—she seemed to be having so much fun with it, too.

Taylor wasn't the only one who used TikTok to her advantage during this album launch. So many of her songs from *Midnights* went viral on the app, with "Anti-Hero" inspiring TikTok trends that encouraged fans to apply the lyrics to their own lives.

When album release week finally arrived, it was time for the Midnights Manifest. Filmed at what resembled the set of the "Anti-Hero" music video, the TikTok video featured a desk calendar where Taylor had written down all the important dates that fans needed to know about over the course of the week. This part was nothing new; she's created similar social media posts around releases so that everyone knows when to tune in for late-night interviews and new music video premieres. But this one included something a bit suspicious just a few hours after *Midnights* was supposed to drop: at 3 a.m. on October 21, she'd penciled in a "special very chaotic surprise."

"Chaotic" was putting it lightly. That surprise turned out to be the *Midnights (3am Edition)*, which included seven additional songs, including collaborations with Aaron Dessner that fans had been begging for, which gave us even more insight into Taylor's life over the years.

Midnights is, for all intents and purposes, a concept album, as Taylor herself has called it. During an appearance on *The Graham Norton Show*, Taylor said that she thought of the sleepless nights throughout her life as a "creative writing prompt" and ran with it.

It was the perfect album to release as she was in the thick of revisiting her past while working on the rerecordings and leading into the Eras Tour. Like the vault tracks, the music on *Midnights* gave fans a better idea of her inner monologue during each era, but unlike the vault tracks, these songs were freshly written. Listening to Taylor reflect on moments in her career and in her personal relationships with the perspective and wisdom she'd gained in the years after was truly refreshing.

If *Midnights* is considered the final addition to the *Lover* house, it tied the pre-Eras Tour part of her career together perfectly. The album proudly bundled up all the messy, big, loud feelings she'd expressed through her music in the first decade and a half of her career and tied them up with a big bow.

NONE OF IT WAS ACCIDENTAL

As a group of fans who have been well trained to search for hidden meanings, Easter eggs, and secret codes in Taylor's music, the release of *Midnights* was something akin to handing Swifties a massive jigsaw puzzle with thousands of pieces, just waiting to be put together. This time, it wasn't simply the secrets of the last two years of Taylor's life that were buried in the lyrics; her entire life was basically fair game. While some people might have been intimidated by that kind of challenge, the Swifties simply said, "Hold my grande nonfat caramel latte" and got to work.

When it came to some of the songs, it was like Taylor *wanted* us to know who she was referring to. "Karma" was very obviously about her feud with Scooter Braun—alongside all the details in the song that alluded to him, using the name Spider Boy in the lyrics basically sealed it. (Taylor's fans like to give her—and by proxy, their—perceived enemies nicknames based on their initials, which is why you'll sometimes see Calvin Harris referred to as Calcium Hydroxide.)

Then there was "Would've, Could've, Should've," which arrived on the *3am* version of the album. So many of the little details lined up with what we knew about her relationship with John Mayer.

Her making a point to specify that she was nineteen years old when the events of the song played out (not to mention the song itself being track nineteen on the album) seemed to be a neon arrow pointing in his direction.

Other songs lent themselves to a bit more debate. Some fans think "Midnight Rain" is about Tom Hiddleston or Taylor Lautner, and though a very loud faction of people are convinced that "Maroon" is *all* Harry Styles, others simply are not sure.

We may never have definitive answers about who inspired what song—and that's not something that Taylor owes anyone anyway—but investigating is fun. It doesn't matter if we ever solve the puzzles, because they might be impossible to solve in the first place (or we might have just made up the puzzle ourselves . . . like that time with the fence). But bouncing theories off of each other while diving deep into the history of Taylor's career, her relationships, and her references is what it's really about.

But the song that might have had the biggest impact on the fandom wasn't about her relationships: It was about herself, and us. "You're On Your Own, Kid" ended up being the song that defined the era, and it wasn't even a

single. Those who have been with Taylor from the beginning already know so much about her rise to superstardom, and the song chronicles her journey from regular teenager to living her dream, along with the ups and downs that happened in between. Then at one point in the song, where Taylor seems to express that she has no regrets about breaking her heart wide open, no matter how much she got hurt living with it on her sleeve in the first place, she reminds us to "make the friendship bracelets," and obviously, we took that direction seriously.

One line from one song, and Swifties ran with it, creating a culture around their fandom and live performances that would even spread to other fandoms.

When she looked around in her blood-soaked gown, the thing that she saw that no one could take away was: *us*.

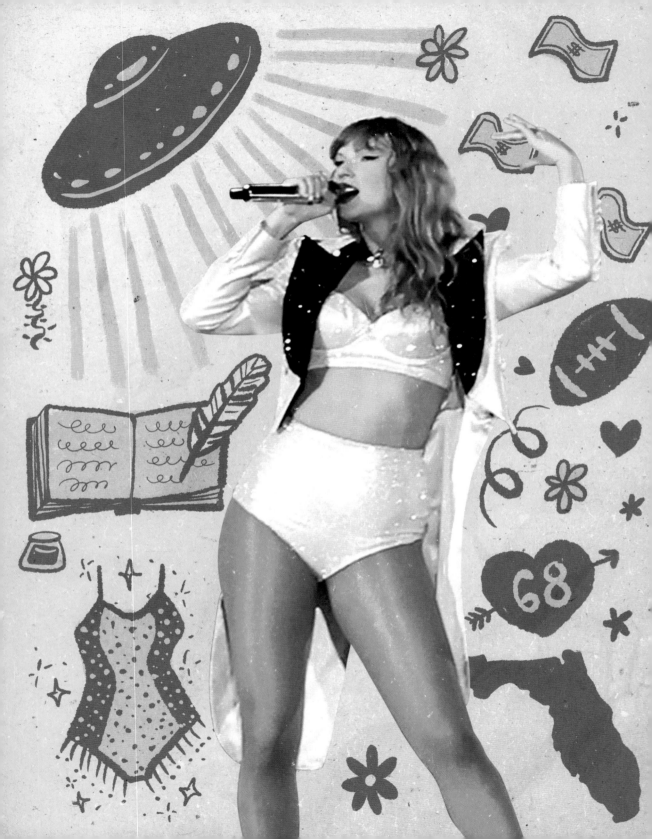

THE
ERAS
TOUR

I knew I was lucky to be able to see the Eras Tour two nights in a row in Atlanta, but before you become too jealous that I got to go twice, let me point out that my friends and I had the actual worst seats in the house. Not only did we have to scale dozens of stairs at Mercedes-Benz Stadium to get to our obstructed-view seats, but we got to watch most of the show on a small video screen, our heads just inches away from the HVAC system. But that didn't stop me from bursting into tears as soon as Taylor appeared onstage, even though I couldn't actually see her.

YOU'RE ON THE WAITING LIST . . . BUT HANG TIGHT

November 15, 2022: a date that will forever make any Swiftie's blood run cold. It was the day the official Ticketmaster Verified Fan presale for the Eras Tour officially kicked off, and it did not go how anyone planned.

To be perfectly clear, it's never been *easy* to get tickets to a Taylor Swift concert, but never before had it been quite this impossible. From the beginning, it seemed like everything went wrong—and in hindsight, it was all a sign that this tour was going to be different from any other in her career.

First, thousands of fans were disappointed when they found out they'd been wait-listed for the presale, but it wasn't exactly smooth sailing for the ones who were selected to receive a code, either. Many fans were waiting in the queue for hours before they could get in to buy tickets, staring at a little purple guy slowly moving across the bar that kept track of your place in line. Or wait, was he moving at all? For a lot of fans, he never did.

A million memes were born that day, but the laughter quickly stopped two days later, when Ticketmaster announced that the general sale for the tour had also been canceled. There were no tickets left, or so it seemed. And not only were fans angry, but so was Taylor herself. It's rare that she posts anything on her Instagram Stories that isn't an album promotion, but she made an exception for this fiasco.

"Well. It goes without saying that I'm extremely protective of my fans. We've been doing this for decades together and over the years, I've brought so many elements of my career in-house. I've done this SPECIFICALLY to improve the quality of my fans' experience by doing it myself with my team who care as much about my fans as I do," she wrote. "It's really difficult for me to trust an outside entity with these relationships and loyalties, and excruciating for me to just watch mistakes happen with no recourse."

After reassuring fans that she was working to get to the bottom of what went wrong, she continued, "It's truly amazing that 2.4 million people got tickets, but it really pisses me off that a lot of them felt like they had to go through several bear attacks to get them."

Taylor may not have been in the Ticketmaster trenches with her fans that day, but going through "several bear attacks" was the perfect comparison to what it had been like to fight for those tickets—in fact, even the fans who *did* manage to get tickets didn't feel much like celebrating when so many had been unfairly left out, especially considering how expensive those tickets had been. There are no victory parades when most of your comrades lose "The Great War."

Ticketmaster's explanation of the fiasco didn't do much to quell the backlash, either. In a formal statement released on their website on November 18, 2022, the ticket seller apologized to both Taylor and her fans, but at that point, there wasn't much they could do to make things right. But whether you've been a Swiftie for ten years or ten minutes, you know that when these fans are on a mission, they don't give up. The outcry from fans was so loud and went on for so long that it surprised exactly no one when the Ticketmaster incident ultimately sparked lawmakers to bring new legislation to the US Congress in a hearing that took place in January 2023.

Was it bizarre hearing sitting senators making references to Taylor's music and trying to cleverly fit her song titles in with their presentations? Yes. But it was also nice for fans to be heard, and many hoped that this would be the first step in holding Ticketmaster and similar corporations like SeatGeek accountable for their ticket-selling processes.

As different cities' tour dates got closer, Ticketmaster contacted select fans who missed out the first time for a second-chance sale with a very limited number of tickets available to purchase. But most fans who didn't get tickets were left to scramble for overpriced resale tickets if they didn't want to miss out completely, with some going for hundreds or even thousands of dollars over

face value, even for the seats at the very top of the stadiums.

And at this point, the tour *still* hadn't even started.

AN INSTANTLY ICONIC TOUR

On March 17, 2023, the Eras Tour opened in Glendale, Arizona. After Lesley Gore's song "You Don't Own Me" played, the lights went out at State Farm Stadium, and fans were never the same.

And by fans, we're not just talking about the seventy thousand people who were lucky enough to snag tickets to the tour's opening night. Because the Eras Tour took place in the time of TikTok—a social media app that hadn't quite caught on the last time Taylor took her show on the road—people all over the world were able watch a grainy live stream of the concert, thanks to fans who were there in person.

The first night of any Taylor Swift tour is a big deal, no matter where you live or whether or not you're attending. Earlier in her career, that meant refreshing Twitter all night, waiting for someone who was there to share an update. But this time, fans everywhere were able to watch all the surprises unfold in real time, freaking out together over the unexpected additions to the forty-four-song set list and, oh my god, that *Lover* bodysuit! Nobody predicted that she'd open

with "Miss Americana & the Heartbreak Prince," but after it happened, it made a lot more sense. With lyrics like "It's been a long time coming," what other song could have possibly been more perfect?

When it comes to her tours, Taylor has always been all about the element of surprise, and the songs she'd choose to play during the acoustic set every night weren't the only element of the show that varied from night to night. The costumes she wore each night for each set would rotate (except for that *Reputation* snake bodysuit, of course—long may she live). And really, these outfits were more like art than costumes, with some of the biggest designers in fashion pitching in to create custom looks for Taylor to wear onstage. This included multiple Atelier Versace bodysuits for *Lover*, sparkly Roberto Cavalli dresses for *Fearless*, and Oscar de la Renta T-shirts and jackets for *Midnights*. We can't forget the Christian Louboutin boots, either . . . or the moment in Rio de Janeiro when the red-bottomed heel snapped off one of them, so she tossed it into the crowd to an unsuspecting fan.

ERAS TOUR CHANTS
YOU NEED TO KNOW

Going to the Eras Tour—or any of Taylor's concerts—isn't just a show, it's an experience. There will be singing. There will be friendship bracelet trading. And yes, there will be crying. But there will also be chanting, or times during the set when everyone around you will say or do the exact same thing at the exact same time. Some of these chants are cringy, but being cringy is the best type of fun. It all started when fans began double-clapping during "You Belong With Me" during the *Fearless* tour, and now, the list just keeps growing.

1, 2, 3, LET'S GO, BITCH!

This started during the *Reputation* tour and might just win if there were a contest for the most sacred chant. In fact, Taylor even acknowledges it onstage more often than not. Get ready to scream this one after the intro to "Delicate," as soon as she sings "You can make me a drink."

YOU FORGIVE, YOU FORGET, BUT YOU NEVER LET IT GO:

This chant references part of Kendrick Lamar's contribution to the "Bad Blood" remix, and fans are sure to shout this line every time Taylor performs the song. Scream this one after you hear "you live with ghosts" in the bridge.

TAYLOR, YOU'LL BE FINE:

This is a nod to Jack Antonoff's aside in the Bleachers remix of "Anti-Hero." Not everyone knows this chant, but it's still respectable.

HOW DID THAT MAKE YOU FEEL?:

If you're not feeling particularly sentimental during the ten-minute version of "All Too Well," you might choose to yell this chant when Taylor sings about how things might have turned out okay if they'd been closer in age. After you ask how it made her feel, she'll reply, "And that made me want to die."

WHAT TIME IS IT?:

Similar to the "All Too Well" chant, you'll ask this question right at the intro of "Style," and Taylor will let you know that it's midnight.

And though Taylor has always been the first to admit that she isn't much of a dancer, she definitely looked like one on this tour. She worked with choreographer Mandy Moore (not *that* Mandy Moore), who told *Entertainment Tonight* that Taylor "freaked out" with excitement when she saw the moves for "Vigilante Shit" for the first time.

But one of the most remarkable things about the Eras Tour wasn't just that it drew in hundreds of thousands of people live streaming the show on social media that first night. The excitement didn't die down. Fans kept coming back night after night, city after city, watching from the comfort of their beds as they cackled at Taylor's cat jokes and mishaps, which would later be (very affectionately) referred to as "errors tour" moments. How many times did she almost fall off that *Folklore* cabin?

Taylor could have shut down those streams early on—in fact, a lot of artists would have as soon as they found out that so many people were watching unofficial, unauthorized content night after night. But she didn't, instead even happily acknowledging the live streams during her concerts. After the ticket fiasco, it seemed like she was all about making the experience more accessible to as many fans as possible.

And these streams really did make it easy for anyone to be active participants in the tour, tuning in to find out which surprise songs Taylor chose to sing that night during the acoustic section of the evening (that "Getaway Car"/"Maroon" pairing at MetLife Stadium on May 26 was a *brutal* loss, and we all knew it) or what color the "Karma" jacket would be that night. It was because of these ever-changing elements of the show that a fan named Allie was inspired to create a game that those watching from home could play together.

It was called Swiftball, a twist on fantasy football that she describes as "an outfit and surprise song guessing game for each night that has morphed into a way to participate in the tour without actually having to physically be at the show."

Before a deadline that Allie set each night, fans filled out their ballots online, predicting everything from the dress Taylor might wear for *Fearless*—would it be gold noodle, silver noodle, or gluten-free fringe?—to whether "something unhinged" would happen, like an album announcement. As fans watched the evening play out via live stream, they hoped to earn a perfect 113 points, something Allie said has never happened. The winner was whoever submitted a ballot and got the

most points, and that person got to lay claim over a fan-donated prize. Usually, the prize was a piece of coveted merch from Taylor's online store, like a special edition CD. Sometimes, it was fan-made merch, like a bouquet of crocheted flowers meant to represent a certain album.

When the game first began early in the Eras Tour, Allie says 855 people played. But by the end of 2023, more than thirty-three thousand fans were joining in, and Swiftball continued for the international tour dates.

"Taylor is unknowable and unpredictable, which is why the game is so much fun—every time you think you've figured out her pattern, she does something to surprise us all," Allie says.

Not only did it seem like Taylor was having a blast performing again for the first time in a long time, but it was also clear she was doing her best to make sure each night was a unique experience for the fans who had attended—especially, as she said during that first show in Glendale, after fans made such a "considerable effort" to be there.

With every detail of the tour, Taylor seemed to keep fans guessing. There were certain songs that many wouldn't have predicted would make the monumentally long set list; even deeper cuts like "Don't Blame Me" and "'Tis the Damn Season" were included. There were also

some stylistic changes along the way that came as a total surprise, like mashing up "August" with "Illicit Affairs" during the *Folklore* set (now that we've heard it, it makes perfect sense).

Some of those changes came after the tour had already started. During the first set of dates, the *Speak Now* era was only "Enchanted," but as soon as Taylor's version of the album dropped in July 2023, "Long Live" became a permanent addition. Of all the songs to add to the set list from *Speak Now*, this one was the perfect choice for a tour that was meant to be a celebration of Taylor's career so far, especially singing it in packed stadiums to fans who had gone to great lengths—like endless Ticketmaster queues—to show up for her once again.

By the end of the tour, certain traditions had been wholly created and established by fans, too, like shining flashlights in the dark stadium while Taylor performed "Marjorie," or the standing ovation that Taylor received after "Champagne Problems" every night, which went on for an impressive *seven* minutes in Los Angeles.

As the tour continued, a culture among concertgoers began to take shape. Born from a lyric in "You're on Your Own, Kid," fans made friendship bracelets to trade with one another at the shows that included song titles, lyrics, and even

inside jokes from the fandom (some more appropriate than others . . .).

The Eras Tour wasn't just a concert; it was more like a Taylor Swift Met Gala. While there were certainly plenty of people in typical concert attire in the audience—T-shirts, casual dresses, or if you're a millennial, jeans and a cute top—some fans spent months (or longer) crafting the perfect costume based on interpretations of their favorite Taylor songs or her most iconic outfits. Basically, any small detail of Taylor's career, social media presence, or lore—fan-created or not—could inspire an entire ensemble.

It was top-tier people watching, from the re-creations of Taylor's most iconic looks to people who went all out, dressing as dogs who had been dyed key lime green. And there was glitter. *So much glitter.*

The Eras Tour was also the first time that Taylor toured while simultaneously releasing new music, and that gave her the chance to announce her latest rerecorded albums as she toured. Fans attending the May 5 Nashville shows got to see her reveal that *Speak Now (Taylor's Version)* was on the way, and fans at the July 7 Kansas City concert witnessed the premiere of her music video for the vault track "I Can See You." Oh, and some casual backflips across the stage from Taylor Lautner, who starred in the video—no big deal.

And on the sixth night of her run of shows at SoFi Stadium in Los Angeles, Taylor appeared onstage wearing a blue outfit during each era before revealing that *1989 (Taylor's Version)* was on its way. When she came onstage in that blue *1989* outfit, the screams were so loud they could be heard outside the stadium.

She wasn't just breaking touring records during this time. In September 2023, Taylor announced that the Eras Tour concert film would be coming to theaters worldwide, and it shattered box-office records when it opened on October 13. In its opening weekend alone, the Eras movie made $123.5 million globally; by the end of the year, that number surpassed $250 million, becoming the highest-grossing concert film of all time.

Not too bad for a blond girl who sings about her feelings, huh?

Just from those numbers alone, it's obvious that fans were showing up to see this movie in droves (and in costume), buying themed popcorn buckets and cups when they arrived at the theater, and dancing and singing in the aisles. Some people even traded friendship bracelets in the bathroom when they realized that the person washing their hands next to them was also a Swiftie—this is girlhood.

But getting back to all those dollar signs, the economic impact of the Eras

THE ERAS TOUR
BY THE NUMBERS

4.35 million tickets were sold across **60** tour dates.

The average resale price of a ticket was **$1,607**—up **741** percent from the *Reputation* tour.

About **75,000** Swifties were in attendance at each show.

Michaels craft stores saw a **40** percent increase in sales of jewelry supplies starting in April 2023—just weeks after the Eras Tour kicked off.

Ticket sales total more than **$13 million** per concert.

Fans who attended one concert said they spent an average of **$291.62** on their outfits, **$214.80** on merchandise, and **$131.48** on food and drinks each.

Tour simply can't be ignored. Before the first US leg was even halfway over, financial analysts estimated that it boosted the United States economy by $4.6 billion in consumer spending—and we haven't even started talking about the boost that we, as a group, gave to the craft industry after buying all those beads for friendship bracelets.

The money being spent during the Eras Tour wasn't just coming from the wallets of Taylor's fans, though. In every city where she played, she donated to food banks that would help feed their community, and as the first part of the tour wrapped up, she gave each of her truck drivers a one-hundred-thousand-dollar bonus as part of a reported fifty million dollars she spent on bonuses for everyone who worked on the Eras Tour in total.

The Eras Tour demonstrated that Taylor can create and fulfill an incredible demand, but it also served as a peek into the culture that fans have created around her music. From trading friendship bracelets to crafting the perfect costume to memorizing chants, it's clear that Swifties have never been a stronger movement.

IN HER FOOTBALL ERA

We'll never know how much of this was a coincidence without Taylor releasing her diaries from this time like she did when she launched *Lover*, but the Eras Tour also seemed to come at a pivotal moment in her personal life. While "Invisible String"—a song that appears to include *very* specific details about the love story between Taylor and Joe Alwyn—was originally the opening track for the *Folklore* portion of the concert, it was quietly swapped out for "The 1," just five shows in, during her first night in Arlington, Texas.

At the time, Taylor joked around about the "hijinks," making it look like the set list could change randomly, putting fans on alert. But after that noticeable swap, nothing else changed . . . and a few weeks later, news broke that Taylor and Joe had gone their separate ways after six years together.

The heartbreak that fans experienced at this time was real, and social media was a *mess*. Many people believed that Joe was *it* for our girl, and now we were presented with a plot twist.

As Swifties, we tend to be an overanalytical bunch—you can blame Taylor for turning us all into cardigan-wearing detectives with all those Easter eggs—and

that extended to carefully examining her performances immediately after the news was out. But even to the casual fan, it was clear that something was different; some of her performances seemed slightly tinged with sadness, though Taylor, ever the entertainer, never gave less than her best.

Because Taylor is Taylor, she didn't release a public statement about her and Joe deciding to go their separate ways, but she gave us something better: a song.

Titled "You're Losing Me," the song was originally only released on a physical CD, a deluxe version of *Midnights* called *The Late Night Edition* that could only be purchased by those who attended the concert in East Rutherford, New Jersey. But the song quickly spread like wildfire among fans online, and you didn't need an English degree to understand that she was singing about the death of a relationship, even hinting that the person she was singing about (presumably Joe) hadn't wanted to marry her. Who doesn't want to marry Taylor Swift?

And when Taylor calls herself a "pathological people pleaser," it's hard for a fan not to feel that in their soul. This song really seemed to put Joe among the ranks of Taylor's most hated ex-boyfriends, which almost certainly caused Jake Gyllenhaal and John Mayer to let out a collective sigh of relief,

wherever in the world they happened to be on May 26, 2023.

The tour didn't just track what appeared to be Taylor's grieving process after the end of what we now know were two very intense relationships (including Matty Healy, but more on him later). It also seemed to chart the beginning of her new romance, which may have only happened because of something the fans created: the tradition of making and trading friendship bracelets (you're welcome, Travis Kelce). Maybe Swifties should consider going into professional matchmaking?

Travis first made his play for Taylor public knowledge on the podcast he cohosts with his brother and fellow NFL star, Jason Kelce, *New Heights*. It was there that he admitted to making a friendship bracelet with his number on it in the hopes of giving it to Taylor when he saw her perform in Kansas City. Hearing the story at the time, many fans were like, "Yeah, Travis, we want to meet her, too, so get in line," but what we didn't know was that this was the beginning of Swifties getting to see a side of Taylor they hadn't seen in a very long time.

The rumors about something going on between Taylor and Travis—who were quickly nicknamed Tayvis by fans—kicked into high gear after that. But there wasn't any confirmation that

A SWIFTIE'S GUIDE TO
FOOTBALL

It's the life of a Swiftie: One day, we heard a little song called "Tim McGraw" on the radio, and suddenly, two decades have passed and we're surprised about how much we actually care about the outcome of the Super Bowl. To a new fan, football can seem totally confusing, but it truly is a lot simpler than it seems.

Basically, the ultimate goal of the game is to **earn as many points as possible** (like in Swiftball). The teams are trying to accomplish that by getting the ball into the **end zone** (and apparently, beating the crap out of one another while they do it).

Each team will have eleven players on the field. One team is playing **offense**— that's the team who has the ball. The other team is playing **defense**, and they're going to try to take the ball.

The offense can try four times to get ten yards closer to the end zone, and these are called **downs**. If they're successful, everyone cheers and they have earned four more tries to go another ten yards. If they're *not* successful, the other team gets the ball, like that time *Red* didn't win the Grammy for Album of the Year that it deserved. Is anyone else still bitter about that? Anyway...

The team scores points in football a few different ways:

Touchdowns: If everyone gets really loud, this probably just happened. This means the team got the ball into the end zone, and it's worth six points.

.

Extra point: After a touchdown, the team can choose to try to kick the ball through the goalposts for an extra point.

.

Two-point conversion: The other option the scoring team can take is to attempt to run and pass the ball into the end zone. Getting two extra points instead of one sounds appealing, but this can be a risky choice!

.

Field goal: The team can choose to try for a field goal during the game by kicking the ball through the goalposts. This can be a slick move if you're losing and need to grab three points *fast*.

.

FREQUENTLY ASKED
QUESTIONS

Why do their outfits keep changing?

Each team has jerseys they wear at home and others when they're away (typically white and more boring than the ones they wear at home).

Do the players get to choose their jersey number?

Yes, although there are some rules they have to follow. Travis chose 87 because his brother, Jason, was born in 1987—how cute is that?

How long is this game on?

Football games are sixty minutes long, but they go for longer because there's a lot of stopping and starting and time-outs going on. And even when it's not the Super Bowl, there are commercials. So many commercials.

Why are there so many time-outs?

It's a strategy thing. Each team gets three time-outs that they can choose to use per half.

So what actually is a tight end?

There are a lot of different positions in football, and Travis's role is tight end. His job is to catch passes the quarterback throws him and to block the defenders from tackling his teammates. It takes a lot of different skills to be able to play this position, so it's no wonder Taylor was impressed.

Why isn't Kansas City in Kansas?

Great question.

Why are so many men threatened by Taylor Swift showing up to a football game?

Because they're afraid of powerful women. And they are fueled by misogyny.

this relationship was actually a real thing that was happening until Taylor made her first appearance at a Kansas City Chiefs game that September. There she was, in the suite right next to Travis's mom, Donna, decked out in team gear and ready to root for number 87. It wasn't a one-time thing, either, and there was something about seeing the goofy (but hunky) football player and the biggest pop star in the world falling in love right in front of our eyes. Let's just blame it on the fact that most millennials' formative years took place during the golden age of romantic comedies in the 1990s and early 2000s.

After six years of Joe Alwyn–level confidentiality, it was kind of jarring to see Taylor putting herself and her relationship out there like this. Kissing on the field after her man won the Super Bowl like she's living in an *actual* fairy tale? It was the kind of thing that felt like it could only happen in a Taylor Swift song, and after years of keeping her personal life under lock and key, this time, she seemed happy to take her fans along for the ride. In fact, fans easily noticed that her performances became more joyful when the Eras Tour picked back up in Latin America in the fall of 2023. She wasn't fighting back tears while singing *Lover* anymore. Something was different about her. Lighter.

After all, "Karma *is* the guy on the Chiefs." Should we ever have expected anything less?

Public displays of affection, going out *in public* without making a mad dash from the car to the door, Travis actually answering when he was asked questions about Taylor—these were all things that we hadn't seen happen for Taylor in a relationship since before Joe, and newer fans hadn't seen it happen at all (sorry you had to miss out on that one-year cake she baked for Calvin Harris and posted on Instagram).

Our girl was *happy*, genuinely happy, and on top of her career game all at the same time, so why wouldn't she face backlash for it? Some NFL fans began grumbling about all the screen time that Taylor was hogging when she was in attendance, and plenty of others made their feelings known in the comments every time the NFL would post anything on social media involving Taylor—even a quick reference in an Instagram caption.

In the end, they shouldn't have wasted time being so upset about it. During the first season of Taylor and Travis's relationship, she only appeared on-screen for an estimated twenty-five seconds per game, according to the *New York Times*. And even though many of us fans could *easily* get riled up about the nasty

comments about Taylor going to games online, blondie herself wasn't sweating it.

"I'm just there to support Travis," Taylor told *Time* when the magazine made her their 2023 Person of the Year. "I have no awareness of if I'm being shown too much and pissing off a few dads, Brads, and Chads."

And while we're on the topic of dads, many of them wanted to thank Taylor for bringing them closer to their daughters, giving them a common interest that they could talk about as they watched the games together each week.

The harmful rhetoric about Taylor that came out during this time was, in a big way, an echo of so much of the criticism we've heard about her before. Despite the chaos that would ensue by her being there, Taylor made the active decision to go to the games and to take up the space instead of making herself smaller the way society makes women feel obligated to. When Taylor Swift was at a Chiefs game, everyone knew it. She arrived completely glammed up, wearing custom accessories in the team's colors, along with vintage pieces. More than once, she brought her famous friends along with her, from Blake Lively to Sophie Turner to Ice Spice. She made herself comfortable as a new member of the wives-and-girlfriends club, buddying up to Brittany Mahomes and even ended up chugging a beer on camera at the Super Bowl. She was there to cheer for Travis and have fun, so did it really matter what anyone else thought?

The brave kind of boldness that comes with living life on your own terms as a woman can be threatening to people, but Taylor did it anyway—and there's no doubt that the little girls at home, finally agreeing to watch football with their dads, took notice.

THE TORTURED POETS DEPARTMENT

Along with the release of "You're Losing Me," fans also gained insight into what was going on behind the scenes in Taylor's life during this time when her eleventh studio album, *The Tortured Poets Department*, dropped on April 19, 2024. There were songs that appeared to describe the sadness (and frustration) Taylor felt as her relationship with Joe came to an end, like "So Long, London," but what many of us weren't expecting were so many songs on the album that seemed to reference another man from her past. What appeared to be a

ERAS TOUR SET LIST

MISS AMERICANA & THE HEART- BREAK PRINCE

CRUEL SUMMER

THE MAN

YOU NEED TO CALM DOWN

LOVER

THE ARCHER

FEARLESS

YOU BELONG WITH ME

LOVE STORY

'TIS THE DAMN SEASON

WILLOW

MARJORIE

CHAMPAGNE PROBLEMS

TOLERATE IT

READY FOR IT?

DELICATE

DON'T BLAME ME

LOOK WHAT YOU MADE ME DO

ENCHANTED

LONG LIVE

22

WE ARE NEVER EVER GETTING BACK TOGETHER

I KNEW YOU WERE TROUBLE

ALL TOO WELL (10 MINUTE VERSION)

■ Performed during the first part of the Eras Tour, but was later cut from the set list.

■ Added after the Paris tour dates starting on May 9, 2024.

THE 1	SHAKE IT OFF	**I CAN DO IT WITH A BROKEN HEART**
BETTY	WILDEST DREAMS	LAVENDER HAZE
THE LAST GREAT AMERICAN DYNASTY	BAD BLOOD	ANTI-HERO
AUGUST	**BUT DADDY I LOVE HIM / SO HIGH SCHOOL**	MIDNIGHT RAIN
ILLICIT AFFAIRS	**WHO'S AFRAID OF LITTLE OLD ME?**	VIGILANTE SHIT
MY TEARS RICOCHET	**DOWN BAD**	BEJEWELED
CARDIGAN	**FORTNIGHT**	MASTERMIND
STYLE	**THE SMALLEST MAN WHO EVER LIVED**	KARMA
BLANK SPACE		

short-term, post-breakup fling with The 1975 front man Matty Healy from the outside looking in was actually anything but.

From the world's perspective, here's how Taylor and Matty's relationship looked: They started dating sometime around early May 2023, which was confirmed when Matty was spotted in the VIP tent during the first Nashville Eras Tour show. Later that month, Taylor and Matty would be seen together out to dinner in New York City, coming out of Electric Lady Studios, and on a few other dates, and Matty even joined Phoebe Bridgers onstage during her opening set at the Eras Tour in Philadelphia. There had been unconfirmed rumors that Taylor and Matty dated during the *1989* era, so some speculated that they were finally getting a second chance.

There was just one problem: This relationship wasn't something that many fans approved of, given Matty's behavior. Not only did he call the idea of dating Taylor "emasculating" in an interview with *Q* magazine in 2016, but he'd also been caught mocking Ice Spice on a February 2023 episode of *The Adam Friedland Show* podcast as hosts Adam Friedland and Nick Mullen made racist comments about the singer—someone who Taylor is friends and collaborators with. And that's just scratching

the surface of the reasons fans didn't approve of them being together.

That's why many of us were relieved (to say the least) when the relationship seemed to end as quickly as it started. At the time, it seemed easily summed up as a rebound after her long relationship with Joe, but *The Tortured Poets Department* made it clear that not only was their breakup devastating to Taylor, it was also an incredibly difficult experience that she was going through while continuing to show up onstage night after night, giving her all as she was falling apart inside.

And while some of the songs on the album appeared to criticize fans who dig too deeply into Taylor's personal life while publicly casting judgment on her relationship decisions (talking about *you*, "But Daddy I Love Him"), it was clear from the start that *TTPD* was for the girlies who get it—us Swifties who have hung in there from the start, of course.

Rather than engaging in a more traditional album rollout with a lead single and a media tour, Taylor made it clear that her longtime fans were the target audience, starting with the album announcement. Hours before she appeared at the Grammy Awards in 2024, her entire website appeared to go down. Usually, this means that an

update to the site is coming, signaling new merch or a new album, so Swifties began diving into the source code right away, slowly sharing each discovery they made as they went.

Taylor knows her fans well enough to know that we'd do that, though, and it didn't take long before people started to discover that the website wasn't *really* down. A page had been created with source code full of Easter eggs on purpose, like the error code "321," which seemed to point to a countdown. It all led to the announcement of *The Tortured Poets Department* that took place when she accepted the award for Best Pop Vocal Album—the thirteenth Grammy award of her career.

"I know the way the Recording Academy voted is a direct reflection of the passion of the fans," she said. "So I want to say thank you to the fans by telling you a secret that I've been keeping from you

for the last two years, which is that my brand new album comes out April 19."

She took a more creative path in the lead-up to the album release, dropping even more Easter eggs for fans to find (and in some cases, decode) along the way. There were the QR codes on buildings scattered around the world that, when scanned, each revealed a letter, ultimately spelling out "for a Fortnight," revealing that "Fortnight" featuring Post Malone would be the first single.

At the same time, Taylor was bringing back an old tradition: hiding messages in her lyrics. Fans discovered that, when playing certain of her songs on Apple Music in the days before the album release, specific letters would be capitalized in a different song each day, revealing a word. By the end of the week, we knew the full phrase was "We hereby conduct this post-mortem," but this was just another piece of the puzzle.

> "I know the way the Recording Academy voted is a direct reflection of the passion of the fans. So I want to say thank you to the fans by telling you a secret that I've been keeping from you for the last two years, which is that my brand new album comes out April 19."

The number two had been a recurring theme throughout the lead up to *TTPD*;

Taylor had held up two fingers when she announced the album at the Grammy

Awards to emphasize that she had been working on the album for two years, and as usual, fans read into that. But this time, we were right to, because when a Spotify pop-up opened in Los Angeles during release week, twos were a recurring theme there, too.

The pop-up was designed to look like a library of poetry, and since it was promoting a Taylor Swift album, everything in it meant *something*. There was a globe with a pin near Florida, referencing the song "Florida!!!" There were both quill and fountain pens present, but no glitter gel pens. These are the three categories that Taylor has said her songs fit into, and this meant that none of the songs on the album would be upbeat, poppy, fun songs (as if we hadn't already picked up on the fact that she was about to make us cry). The list went on and on. There were also lyrics in a book propped open behind glass, which turned out to be one of the most meaningful Easter eggs of all.

The lyrics on display at the pop-up would change twice a day: when the pop-up opened, and again at 2 p.m. They were always just a line or two from a song, though it wasn't clear *which* song. And when *TTPD* finally did release at midnight on April 19, after listening all the way through, fans realized something: none of the lyrics from the Spotify pop-up were actually in any of the songs on the album.

Then, at 2 a.m., Taylor revealed she had another surprise up her sleeve. The release was actually a double album called *The Tortured Poets Department: The Anthology*, and with it came fifteen additional songs (and there were all those lyrics we were missing). I can still remember being semi-delirious and exhausted, awake in the middle of the night listening to the surprise tracks, which I don't think I even absorbed until I listened again after a solid night's sleep. Still, it was so fun to be awake for that moment.

There were just under three weeks between the time that *TTPD* was released and the Eras Tour picked back up in Europe. And when Taylor took the stage in Paris on May 9, 2024, she debuted an entire new iteration of the Eras Tour. It was so different that it was like watching a brand-new concert. Even through a grainy TikTok live stream, it was easy to see. The changes were obvious right away: not only was Taylor wearing a brand-new bodysuit for the *Lover* portion of the evening, but "The Archer" had been cut from the set list. As the show progressed, more and more changes were revealed. *Folklore* and *Evermore* had been combined into one era, and songs like "Long Live" and "Tolerate It" had

been sacrificed—and there were *so* many new outfits. As this all unfolded, some fans were upset that their favorite songs had disappeared from the set list, but soon enough, Taylor proved that it was all for a good cause.

After the *1989* part of the set concluded, Taylor would typically head to the end of the stage with her guitar for surprise songs, but instead, she launched a brand-new portion of the show entirely dedicated to her music—something she'd tell fans in Paris had been in the works for "eight or nine months." When we thought Taylor and her dancers were relaxing during the break in shows in early 2024, they were actually rehearsing for these new performances.

All that rehearsal paid off, because with new costumes and set pieces, Taylor brought her most recent album to life in a way that fans never expected, down to a moving platform that made it look like she was levitating during "Who's Afraid of Little Old Me?" and a staged alien abduction during "Down Bad."

Best of all was her onstage interpretation of "I Can Do It With a Broken Heart," a song that was about putting on the best show possible for her fans even in the moments when she'd rather be anywhere else. It started off with Taylor's dancers dragging her seemingly lifeless body to get dressed, then reviving her to perform like she was part of the circus. We might not be on Taylor's level, but we all know what it's like to pull ourselves together when we don't want to get out of bed and do what needs to be done, whether that's going to work, parenting our kids, or performing on an international tour. Once again, a song inspired by a deeply personal situation in Taylor's life was something that many fans could relate to, because that's her superpower. In the end, Taylor has always been able to do it with a broken heart—and usually better than anyone else can do it on their best day. But it was good to know that, by the time she was performing the song on the Eras Tour, her heart wasn't broken anymore.

RERECORDINGS AND BEYOND

Listening to the original versions of Taylor's albums when they first released helped me put what I was feeling at the time into words. But now, every time a new rerecorded album is finally released, I find myself seeing my biggest heartbreaks and happiest moments in a new light—and it feels like that's what Taylor is experiencing too.

SOMETHING OLD, SOMETHING NEW

Through her career, Taylor has always stood for the rights of artists. Sometimes, that meant pulling her music from streaming services until they found a way to make sure that every artist who used the platform was fairly paid, and sometimes, that meant being completely transparent when she felt she was being taken advantage of by a man whose record label she helped build.

Just four months after she shared her initial Tumblr post about the masters now being in Scooter's hands, she returned to social media to ask for fans' help—something she rarely, if ever, has done. When the American Music Awards announced they'd be honoring Taylor with the Artist of the Decade award during the 2019 broadcast, Taylor planned to perform a medley of her biggest hits but had been blocked by Scooter and Scott, and they weren't allowing her to use older music or performances in *Miss Americana*, either, which hadn't yet premiered on Netflix.

"Scott Borchetta told my team that they'll allow me to use my music only if I do these things: If I agree to not re-record copycat versions of my songs next year (which is something I'm both legally allowed to do and looking forward to) and also told my team that I need to stop talking about him and Scooter Braun."

She went on to ask her fans to let Scott and Scooter "know how you feel" about the situation, along with encouraging

the artists Scooter managed—which included Ariana Grande and Justin Bieber at the time—to speak up, too.

Ultimately, Taylor was able to perform some of her older songs at the AMAs, including "Shake It Off" and "Love Story," while wearing one of her most iconic outfits: the white button-down shirt emblazoned with the names of her stolen albums all over it, front and back.

And in her acceptance speech, she was sure to thank the same people she always does. "All that matters to me is the memories that I've had with you guys, the fans, over the years. Because we've had fun, incredible, exhilarating, extraordinary times together and may it continue. Thank you for being the reason I'm on this stage. I'm so lucky I get to do this," she said.

Taylor's rerecording project was obviously going to be a massive undertaking, but she immediately had the support of her fans and even other artists in the music industry. In a tweet to Taylor in July 2019 in the wake of that first Tumblr post, Kelly Clarkson wrote, "Just a thought, U should go in & rerecord all the songs that U don't own the masters on exactly how U did them but put brand-new art & some kind of incentive so fans will no longer buy the old versions. I'd buy all of the new versions just to prove a point." We know now that Kelly was

really onto something, and so did Taylor. And, apparently, so did Scooter, because years later, in June 2023, Kelly told Andy Cohen that Scooter called Kelly's manager after she posted that tweet, and she came away with the feeling that Scooter thought she was "attacking" him.

If he felt threatened by the idea of Taylor rerecording all her albums, he should have. The rerecorded albums have been wildly successful, with *1989 (Taylor's Version)* outselling the original, and Taylor sends Kelly flowers every single time another one is released.

Legally, she wasn't able to start rerecording her first five albums until November 2020 (with *Reputation* following in November 2022), and around that time, she had another update. More negotiations with Scooter had gone south, and then she found out that a private equity company named Shamrock Holdings had actually purchased her masters (along with her album art and music videos) under a contract that would allow him to continue to profit.

Taylor took this new development in stride. She had already begun the rerecording process at that point, and in April 2021, the first album was released. *Fearless (Taylor's Version)* was officially out in the world, and from the way fans responded, this risk had been one worth taking.

Maybe if Taylor had chosen to rerecord her old albums just as they were, no bells and whistles, the project wouldn't have been as successful as it became. But she has never been one to do anything halfway, so of course, she created mini-eras around each new drop, allowing us to have fun with her along the way.

So often many of us recommend something we love to a friend—an album, a book, a movie, a TV show—and wish that we could trade places and watch or read or listen to our favorite thing for the first time all over again. Taylor actually gave us a chance to do just that. Reliving your favorite album, hearing it again for the first time, is pure magic, and it doesn't happen all the time. And this time, it's a little different; we can hear the subtle changes in Taylor's voice as she sings the same songs we already know and love years later, along with the brand-new vault tracks that keep the experience fresh and exciting.

Life without being a Swiftie must be so boring.

Each rerecorded album came with new album artwork, and they each came with their own set of vault tracks, or the songs that *almost* made each original album but didn't, with many of them featuring artists she'd worked with at the time (or wished she could have), like Keith Urban, Hayley Williams,

Phoebe Bridgers, and Fall Out Boy. Each new vault track gave fans more insight into Taylor's thought process when she was making the original albums—along with the obvious added bonus of giving people who already invested in her first six albums the first time around a reason to get excited and actually want to buy them all over again. What she was creating was truly a new product, even if it stemmed from a version of an album that had already been released years ago.

Like everything that Taylor does, she worked hard to make this process a full experience, starting with each rerecorded album's announcement. Though the first couple (*Fearless* and *Red*) were more low-key, once Taylor was on the Eras Tour, announcing which rerecording was coming next became a bigger affair. Revealing the vault tracks was an exciting moment, too. For the first two rerecorded albums, the track titles came in the form of a video that Taylor would post on social media. An image of an actual bank vault in the album's corresponding color would open, and letters would fly out, giving fans a puzzle to solve. After unscrambling the letters, fans could figure out the track titles (and which artists Taylor might have collaborated with on the songs, like Paramore or Keith Urban).

1989 (Taylor's Version) got one of the biggest vault track reveals when Google got in on the fun. Anyone who searched the term *Taylor Swift* was presented with a graphic of a blue vault, resting on a pile of sand at the beach. Clicking on the vault would unlock a puzzle for you to unscramble, with eighty-nine unique puzzles for each user to solve in all. Once thirty-three million puzzles had been solved by people worldwide, the vault would unlock and reveal the track list. Some might think that it would take days to solve that many puzzles, but of course, these are Swifties we're talking about, so the vault was unlocked just nineteen hours later.

And it would have been a lot faster than that if we hadn't accidentally broken Google in the process. Sorry about that, by the way.

Having the chance to relive the eras all over again is cool enough, but seeing how much fun Taylor seems to be having with it all—a task she was almost forced to undertake because of something terrible that happened to her—just makes it all the more fun for the rest of us, too. It's not just that Taylor is looking back at her original music from an older, wiser, and more experienced perspective; those of us who have grown up along with her are doing the same as we think back to the people we were and what was happening in our lives when we heard these albums the first time around.

Through it all, Taylor is sending the message that having ownership over your art matters. As she's said before, she might be in a place in her career where she doesn't need to prove any points, but her going through this massive undertaking so successfully and so gracefully is only paving the way for other artists who might need her to stand up and fight when they can't do so themselves. And with each major win, Taylor is always thanking us for making this project as big of a hit as it has turned out to be.

REACHING LEGEND STATUS

From an outsider's perspective, this time in Taylor's career absolutely looks like the peak. She's released more than ten chart-topping albums (and became the first artist to win four Grammys for Album of the Year in the process), re-recorded her back catalog to great success, embarked on the highest-grossing concert tour of all time, *and* has officially become the first artist to ever become

a billionaire off only her music. This is the mountaintop, and it's all downhill from here.

But like I said, that's from an outsider's perspective. We Swifties know better: She's just getting started.

It did feel like the Eras Tour and the rerecordings wrapping up would be the end of something. As the *Midnights* era came to a close, it felt like something had shifted then, too. What we have witnessed so far, as fans, has been the building stage of a career and a legacy that's going to stand the test of time. Taylor Swift has now entered into music legend status, and with that kind of power behind her, what she does next is limitless.

The fun of being a Taylor fan comes in experiencing how she continues to reinvent herself, finding new ways to stay relevant and exciting while remaining, at heart, the earnest teenage girl who so many of us fell in love with decades ago. That's why Taylor never had to worry that *Lover* would be her last grasp at explosive success as she hit her thirties, and it's why she won't have to worry about the "next Taylor Swift" swooping in and stealing her place. She has made herself completely irreplaceable. No one else has done what Taylor has.

Some have called this part of Taylor's career Taylormania, a play on

Beatlemania, the word that was used to describe the height of The Beatles' fame in the 1960s. And much like Beatlemania, the source of power behind Taylormania *also* happens to be girls and women.

Members of any female-dominated fandom, whether it happens to be Taylor's or not, are never taken as seriously as they deserve to be. It's true of just about everything that (mostly) women like, whether it's a Stanley tumbler or getting excited about pumpkin spice lattes returning to Starbucks or looking forward to a new Taylor Swift album. There is always someone waiting to tell us why what we are passionate about is stupid, and when they say things like that to us, it's hard not to feel a little silly . . . if only for a moment.

The Swiftie universe is proof that nothing the detractors say is true. We do hold power, and over the years, we've used it in beautiful ways, from the little things like coming together to make sure that Taylor wins a fan-voted award to the big things, like raising money for fans in need. And never forget that Taylor Swift, one of the biggest musical artists not just of our time, but of *all* time, started out as a teenage girl who was simply singing about her feelings. Her honesty and vulnerability built her empire, and there is more power in that than there ever will be in tearing down others because they

are interested in something you don't understand.

As an artist and an icon, Taylor has never been afraid to take up space—even when her success had critics labeling her as "overexposed" or when one of the men she sang about threw tantrums about being the supposed subject of a song. In a world where women are so often expected to shrink down, physically and figuratively, Taylor is no longer willing to play along. It would be impossible to overestimate what a positive impact having a role model like her can be to girls in their formative years (let alone women who are still dismantling the ways the patriarchy has warped their own brains). Witnessing her strength alongside her heartbreaks over the years has inspired so many of us to show the same kind of strength, knowing that sometimes being strong means allowing yourself to feel the full weight of your feelings, all messy and unresolved, instead of pushing them away.

Beyond all the records she's broken and the awards she's won, the real impact that Taylor has had on our lives will continue to be felt in ways that many of us may not have even fully realized. Maybe it will be her words in the back of your head giving you the push you needed to ask for a much-deserved raise or tell someone how you really feel about them. Or maybe it will be the girl standing next to you as you say your wedding vows, the best friend you only met because you spotted her at a coffee shop, wearing a *Folklore* cardigan. Maybe it will be the songs you sing to your four-year-old daughter to get her back to sleep in the middle of the night when she's sick and you're both exhausted.

Whatever the future holds for Taylor Swift, it's going to be big, and bright, and full of Easter eggs that we have yet to find. As long as she is able to continue helping her fans put their feelings into words, Swifties will keep showing up for her, too.

And at the center of all of it will be the very real love story that exists between a teenage girl, her guitar, and us—the fans who never left her side.

ACKNOWLEDGMENTS

As a kid, I told everyone who would listen that I was going to grow up to write books, and I am overwhelmed with joy to know that I've finally made Little Nicole proud. Every moment of this experience was a lifelong dream come true, and I feel so lucky to have been able to combine my passion for writing with my fascination for all things Taylor Swift into the book you're holding in your hands right now.

I owe everyone involved in this book so much more than a thank-you, but for now, words will have to do.

To my editor, Cindy Sipala, and the team at Running Press—thank you so much for trusting me and my vision for this book and offering so much guidance and support along the way. As a first-time author, you've made this process an unforgettable one.

To my agent, Amanda Bernardi, who took a chance on signing a brand-new author—you believed in me and this book so much from our very first conversation, sometimes more than I did. You gave me endless pep talks, made me laugh in stressful moments, and helped me turn my ideas into something real. Thank you for letting me turn you into a Swiftie!

To my husband and best friend, Blake Gilder, who has believed that this dream would come true since we were teenagers. For months, you took on all the childcare duties without complaining, brought me coffee and flowers, and patiently listened to so many meltdowns (and *so* much Taylor Swift). I couldn't imagine a better partner.

And to our daughter, Penelope, who was so understanding when I had to work long hours to get this book done, who told me I did a good job every time I walked away from the computer at the end of the night, who encouraged me to

keep going in every challenging moment. Being your mom is the joy and the honor of my life. I will sing Taylor songs to you at 3 a.m. when you can't sleep for as long as you'll let me.

Thank you to my parents and sister, who have been my number one fans since I was a kid sending manuscripts to publishers totally unsolicited in elementary school. I wouldn't be who I am today without you, and this book wouldn't exist without all the extra help you provided with Penelope, making sure I had enough quiet time to write. I love you so much!

I am also lucky enough to have the absolute best support system of friends who offered so many supportive words, Starbucks gift cards, and unconditional love while I was writing this book. From the best friends who have always been by my side to my mom group BFFs: The way you showed up in such big ways to become my biggest cheerleaders through

this process will never be forgotten.

Special thanks to Martha Sorren and Lindsay Denninger, my media coworkers turned lifelong friends who happily read every part of this book I sent them and reassured me that I am not an awful writer when I was having doubts. Every author deserves friends like these two.

Thank you so much to Taylor's fans—both the ones I spoke with for this book and the ones who have made the Swiftie universe such a fun place to exist. I have the time of my life clowning with you!

And of course, thank you to Taylor Swift for providing the soundtrack to my happiest moments and biggest heartbreaks for the past two decades of my life. Thank you for making me feel understood, for connecting me to some of my favorite people, and for inspiring the idea that would lead to this book, making one of my biggest dreams come true. You have a fan in me for life.